Selwyn Leamy

Master Oils

Painting techniques inspired
by influential artists

ilex

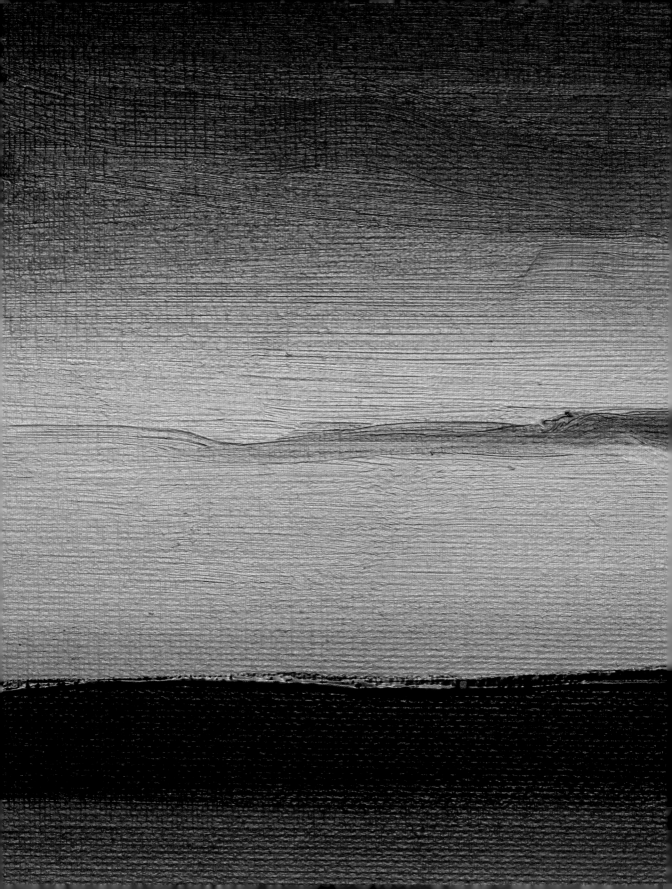

Contents

4 Materials and mediums

6 Supports and grounds

8 Palettes and palette management

9 Brushes

Brushwork & Creating Form

14 Paul Cézanne: Directional brushstrokes and dark base colours

18 André Derain: Textures and greens in nature

22 John Singer Sargent: Painting *alla prima*

26 Walter Sickert: Unblended brushstrokes

30 Lucian Freud: Impasto flesh tones

34 John Everett Millais: Oil medium

Colours & Mixing

40 David Cox: Range of greys

44 Georges Seurat: Optical mixing

48 Stanley Spencer: Dominant colour

52 J.M.W. Turner: Sense of atmosphere

56 James Abbott McNeill Whistler: Thinning and blending

60 Armand Guillaumin: Complementary colours and colour theory

Subject & Approach

66 John Constable: Sketching *en plein air*

70 Mark Gertler: Limited palette

74 George Smith of Chichester: Aerial perspective

78 Euan Uglow: Dividing the subject into sections

82 Francis Bacon: Transforming an existing image

86 Roy Lichtenstein: Copying

Composition & Arrangement

92 Meredith Frampton: Arranging a scene

96 William Chase: Rule of thirds

100 Lisa Milroy: Repeated series

104 Robert Delaunay: Cropping

108 Edward Burne-Jones: Composition with rhythm

Pattern, Surface & Abstraction

114 Henry Bishop: Colour and texture

118 Raoul Dufy: Repeated marks and strong colour

122 Spencer Gore: Stylised shapes and geometric pattern

126 Charles Ginner: Distinct shapes and patterns of colour

130 Piet Mondrian: Preparation

134 Gerhard Richter: Applying paint in different ways

138 Claude Monet: Simple palette

142 Glossary

143 Picture Credits and Acknowledgements

Materials and mediums

OIL PAINT

In simple terms, oil paint is made up of two components: pigment and oil. The pigment (the colour) is a powder, and the oil (the binder) is what the pigment is suspended in.

Pigments

Historically, pigments were natural – prepared and made from organic matter and minerals that were ground down into a powder. Nowadays, they are nearly all synthetic, which makes them cheaper and easier to produce, and slightly more consistent in terms of their colour and hue. The best pigments are intense in colour and permanent – so they won't fade over time. Even today, some pigments are more expensive than others, which is why oil paints are categorised by series numbered from 1 to 4. Series 1 pigments are the cheapest because they are the easiest to make (usually earthy colours) and series 4 pigments are the most expensive because they are the hardest to make (often bright colours). Some oil paints may also be cheaper because the pigment is mixed with a filler, such as talcum powder or clay, to bulk out and give them more body. This makes the colour less intense, as less pigment has been used.

Binders

Most oil paints are made with linseed oil as the binder, but other oils can also be used. Linseed oil yellows slightly over time, so some oil paints are made with poppy oil or safflower oil because they don't yellow as much.

MEDIUMS, OILS AND SOLVENTS

When oil paint comes out of the tube, it has a rich, buttery consistency and can be applied straight to the canvas. However, artists often add oil, a ready-mixed medium or a solvent (also known as a thinner or diluent), to change the consistency, drying time and finish of the paint.

Mediums

The various mediums available modify your paint in a numbers of ways: they can make the paint more fluid or easier to blend or work in details; they can smooth out brushstrokes, or simply make the paint dry faster or slower. Traditionally, these mediums would have been oils and solvents in different proportions, like a recipe. Today, however, there are many ready-mixed mediums. One of the most common is an alkyd medium such as Liquin. You can add an alkyd medium to traditional oil paints to increase the translucency of the paint, as with

a standard oil, but an alkyd medium will make the paints dry noticeably faster and with a high-gloss finish.

Oils

The most common oils that artists add to oil paints are refined linseed oil and stand linseed oil, both of which give a glossy finish but are slow to dry and give a slightly yellow tint. Stand linseed oil has been heat treated and has a much thicker treacly consistency than refined linseed oil.

Poppy oil and safflower oil also increase gloss but are much paler and don't yellow the finish as much. Safflower oil dries slower than linseed oil, so it is often used in the last layer of a painting. Walnut oil gives a high-gloss finish, gives paint a fluidity that makes it good for detailed work and has a similar drying time to linseed oil.

Adding oil will make your paint more transparent because it is giving the pigment more binder in which to be suspended.

USING SOLVENTS SAFELY

Both turpentine and white spirit are volatile and flammable, so they need to be handled, stored and disposed of with care. You don't need to wear gloves, but it's best to avoid getting solvent on your skin. If you get oil paint on yourself, you can wash it off with washing-up liquid.

To dispose of white spirit or turpentine, you can simply leave the mixture for a while in a sealed container, wait until the paint has sunk to the bottom, then pour out and re-use the clear solvent from the top, leaving the sludge to dry. When it's dry, you can throw the sludge away.

Solvents

Solvents thin the paint, making it easier to paint with. They also evaporate from the surface, speeding up drying time. The most common solvents for oil painting are white spirit and turpentine. White spirit is a mineral-based solvent and is less stable than turpentine, meaning that it will potentially degrade over time, whereas turpentine will not (however, we are talking about a long, long time). Paints thinned with turpentine or white spirit will dry to a matt finish and will not have the shine or sheen of pure oil paint.

Both turpentine and white spirit have a strong smell and are harmful to inhale, so should be used in a well-ventilated area. There are also low-odour thinners for those who really can't stand the smell of turpentine or white spirit – but some fumes are still there, so it is still advisable to work in a well-ventilated space.

Finally, you have the option of citrus-based solvents, which smell like oranges because they are distilled from the natural oils in orange peel. Although they work for washing brushes, they are probably not as good as turpentine or white spirit for use in painting. Both low-odour and citrus-based solvents are slower to evaporate and more expensive than traditional thinners.

Fat over lean

An old rule of thumb is to paint 'fat over lean'; the 'lean' is the solvent-thinned paint and the 'fat' is paint mixed with oil or another medium. This is because the lean layers are inflexible and dry more quickly; if you have a 'fat', flexible layer underneath, it will still be wet when the top layer dries, which may cause the top layer to crack – so you want quicker-drying layers at the bottom and the slowest-drying layer on the top.

The shine will increase with the more oil or medium used. This can lead to inconsistencies of finish, with some patches of your final painting looking matt and other areas looking shiny. To avoid this, try to be consistent with how much oil you use across your painting.

GLAZES

A glaze is technically a medium, as it is mixed with your paint, but it is specifically used to build up layers of translucent colour. Each layer of paint must be dry before the next is applied, which can make painting with glazes a painstaking process. Glazes are used to add depth and richness to the surface of a painting, especially in skin tones.

As a glaze is transparent, the colour underneath will show through. This will affect the final colour of the glaze layer; for example, if you apply a layer of yellow glaze over an area of blue, you will end up with a green colour.

A simple glaze is made up of one part linseed oil to one part turpentine. This will dry slowly, but it will give a transparency to the paint, as well as softening the brushstrokes and increasing the gloss of the paint.

Supports and grounds

SUPPORTS

The surface that you paint on is called the support. You can paint on pretty much anything, but artists generally look for supports that are stable, flat and light.

Canvas/linen

Canvas is the traditional support for artists. It is a thick cotton material that is usually stretched over a frame or board. It can also can be taped to a board, and stretched and mounted later. Canvas is light and has a weave to it that gives it texture.

Linen is made from flax. It is usually darker in colour and more expensive than canvas. This is because linen can be woven finer than cotton, giving a smoother surface to work on. Linen is also thought to be more durable than canvas.

You will need to prime both of these kinds of support. Canvas and linen are incredibly porous

and, if painted on without any preparation, they will soak the oil out of the paint, making the paint dry quickly and leaving it with a dull, matt finish.

Boards

Centuries ago, artists painted on wood, but the danger of painting on wood, such as oak, is that it isn't stable and can split or crack. Nowadays, board materials, such as plywood or MDF, can give a stable and smooth surface. Some artists prefer working on board to canvas, because it is solid and doesn't have the same springy give that a stretched canvas does. Wood, like canvas and linen, is porous and should be prepared with a primer.

Paper/card

Paper used for oil painting has to be very thick (280 gsm or above) to hold the weight of the oil paint. Paper is a light and portable support, making it good for working outside. Ideally it should be primed, but it can be worked on without primer, so long as it is sealed with glue or size.

GROUNDS

The material you use to prepare your painting surface is called the ground.

Size/glue

The traditional way to prepare a support was to size it first by painting it with glue. Traditionally, the glue would have been made of rabbit skin or similar, but now you can use PVA. The size seals the surface of the support and creates a barrier that, in the case of most supports, stops it being porous. PVA glue is white when applied, but it dries clear so it works well if you want the natural colour of your support to come through.

Dilute the PVA – two parts PVA, one part water. With a large flat brush paint this onto your paper.

Gesso

Gesso is chalk in suspension that goes on after the size. Once dried, it can be sanded to get rid of the brush marks or left rough to add texture. Additional coats of gesso can be applied until you have a smooth, white surface. There are many different acrylic gessoes available that are suitable for oil painting.

Acrylic primer

A primer is a thick, white substance that can be used without any additional materials, because it does the job of a size and gesso combined. Like a size, it seals the support, providing a non-porous surface. Like gesso, it gives a smooth, white surface and can be sanded and applied in multiple coats.

Oil primer

Oil primer is the same as acrylic primer, but because it is oil-based, it will take longer to dry.

Palettes and palette management

PALETTES

'Palette' has two meanings: it's the physical object that you put your paints on, and it's the combination of colours that you use.

Your choice of physical palette will depend on where and how you are painting. In an ideal world, your palette should be as big as the painting you're making, though that may not always be possible. Your palette needs to be non-porous so that the paint stays wet and fresh on it. There are several options for palettes, some purpose-made and some improvised.

Whatever you use as a palette, it is a good idea to clean it at the end of the day. You can wipe it with a bit of solvent on a rag or paper towel.

Kidney-shaped palette

With its distinctive curved shape and a thumbhole to make it easier to hold, this is the classic painter's palette. Designed to rest comfortably on the artist's forearm, it comes in a variety of sizes and is usually made from varnished wood or plastic.

White tile or dinner plate

White ceramic is great, as its whiteness makes it easier for you to see the colours, and the ceramic is fantastically non-porous. They are quite cheap and easy to clean.

Greaseproof paper

Greaseproof paper is great because it designed not to let oil through; you don't need to worry about cleaning it up afterwards, and your palette can be any size you like.

Tin

This is a little unconventional, but a small cigar or mint tin can be great for using outside.

PALETTE MANAGEMENT

The way you lay your paints out on your palette is an important part of your preparation and will make it easier to get the colour or tone that you want.

Put your paints around the edge of the palette, leaving as much space in the middle as possible for mixing. It can be a good idea to have two blobs of white – one for mixing and one purely for painting any highlights. When mixing a colour, try to make enough to last the whole way through a painting.

Brushes

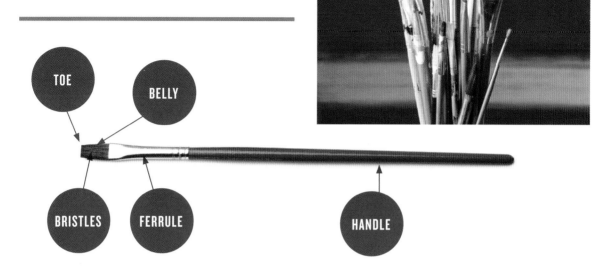

The best brush to use is the one that you're most comfortable with and does the job you want it to do. Apart from all the different sizes and shapes, brushes basically break down into hard-bristle brushes and soft-bristle brushes. There is a large array of hair used in brushes, including hog, squirrel and badger – and then, of course, there are synthetic brushes

Ignore distinctions between watercolour, acrylic and oil brushes. All of these can be used for oil painting, but they will give different effects and might be better for certain techniques. Soft brushes can give a smoother application and are better for more detailed work. Hard-bristle brushes can be better for thicker applications of paint and large gestural painting.

Consider the shape of your brush; for example, round brushes are perfect for detailed areas.

BRUSH CARE

Looking after your brushes is essential in order to keep them in good working order. Bad habits, such as leaving them soaking in a jar of dirty white spirit, will ruin their shape and leave them unusable. Three easy steps are wipe, rinse, wash:

1. Wipe excess paint off onto a rag or paper towel.

2. Rinse your brush in white spirit and wipe again.

3. Wash your brush under warm water (not hot water because that will expand the ferrule, which can lead to the bristles falling out) with soap or washing-up liquid. Gently pinch the bristles from the ferrule to the toe of brush, squeezing the residue of paint out until the water runs clear.

Broad and thin strokes with
a round brush.

Using the edge of a flat brush for
an accurate line.

Using a blade for a straight line.

BRUSH TYPES

Hard brushes (hog)

These are hard-wearing brushes and are
traditional oil-painting brushes. Poor-quality
hard brushes splay easily and can quickly
become impossible to use as they lose their
shape. A quality hard brush holds paint well
and will keep its shape for a long time, if looked
after. They will wear down as they are used,
but worn-down brushes are still useful. A hard
brush often leaves visible brush marks behind.

Soft brushes (synthetic, sable and squirrel)

Don't think that hog hair brushes are the only
brushes you can use for oil painting. You can
use any brush, even if it says it's for acrylic or
watercolour. Soft brushes are very good for
precision painting and detailed work. They
are great for blending and don't leave obvious
brush marks behind.

Flat brushes

These are great for broad, sweeping strokes,
and can also create a straight line if used on
their sides. Flat brushes are very versatile, good
for laying down large areas of background as
well as building up the form and structure of
a painting.

Round brushes

A round brush can create broad brushstrokes when the brush is loaded with a good amount of paint and the stroke is applied with pressure. They can also be shaped into a sharp point for detailed work.

Filbert brushes

Like the flat brush, this can be used for broad brushstrokes, or for a line when used on its side. It can also create a tapering line if the pressure is varied or the brush is twisted onto its side as the brushstroke is applied.

Bright brushes

Similar to a flat brush, except with slightly rounded sides. They also usually have shorter bristles, so are often favoured by landscape painters for creating texture with dabbing brushstrokes.

Rigger brushes

These have much longer bristles than a small round brush. Rigger brushes can be useful for detailed work, but their main use is for long, continuous lines, as the bristles hold more paint and the brushstrokes can use the whole length of the bristles.

Angle brushes

These can cover large areas with broad brushstrokes, but the sharp, pointed end is also good for finer details.

SIZES

Brush sizes will start small, increasing in size through 0, 1, 2, 3, and so on. The higher the number, the wider the brush. Sizes differ from brand to brand. You will find your preference as your style develops, but it is always useful to have a range of sizes in several different types of brush.

PALETTE KNIVES

Brushes aren't the only way to get paint onto a surface. Palette knives can be used to apply the paint in a thick, impasto way, almost like spreading butter. There are two main types of palette knife: the long, straight-bladed knife with a rounded head, and the diamond-shaped knife with a sharp, pointed head. The shape of the palette knife will determine its effects, as will the angle you hold it as you apply the paint. It's worth experimenting to see what works for you.

Knives with a 'crank handle', or a bend in the blade or handle, are designed for painting as the bend helps keep your knuckles away from the painting. Straight-handled knives are more often used for mixing on the palette, although they can also be good for creating large smears of paint.

Palette knives are also useful for scratching and scraping back into your painting to create texture and marks. You can also improvise with other ways of putting paint on and scratching it back – it doesn't have to be a dedicated art tool. And don't forget your fingers – they are useful, too.

Brushwork &
Creating Form

Paul Cézanne: Creating form using directional brushstrokes and dark base colours

Paul Cézanne's painting is seductively rich in tone and texture, with its thick, visible brushstrokes and powerful lights and darks. To explore these techniques, make a tree (a classic Cézanne motif) your subject. Working over a dark underpainting, use the direction of your brushstrokes to describe the form of the tree.

RECOMMENDED PALETTE
- ○ Titanium white
- ● French ultramarine
- ◍ Lemon yellow
- ● Burnt umber
- ● Burnt sienna

YOU WILL ALSO NEED
Primed canvas
HB pencil
Flat brushes
A solvent
Rags/paper towels

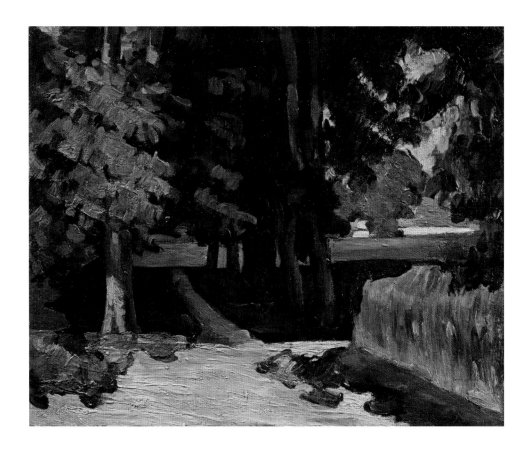

This painting of a tree-lined avenue at Cézanne's family estate perfectly captures the feeling of a hot, sunny afternoon. Cézanne slightly compresses the space in this composition, particularly the grasses and the shadows in the foreground, which seem quite flat. Concentrating on the tree at the left of the canvas, we can see his skill at creating a tangible sense of three-dimensional form.

The bright foliage shimmers against the black silhouette of the trees, as the sun- baked path disappears under the shady canopy. A large swathe of shadow dominates the image, and from this

The Avenue at the Jas de Bouffan c.1874–5

Paul Cézanne oil on canvas

Cézanne builds the structure of the foliage and trunks with thick, slab-like blocks of colour. These brushstrokes stand out against the dark paint, but moving across the image, they subtly blend and disappear into the background beyond.

Cézanne uses heavy, diagonal brushstrokes to create the clumps of the leaves. The trunk is described with a more vertical brushstroke, the lighter red-brown paint working in contrast to the blue shadow. In this painting, Cézanne used a palette knife as well as a brush to apply paint thickly, adding to the overall form and texture of the piece.

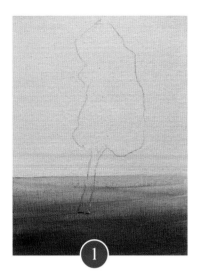
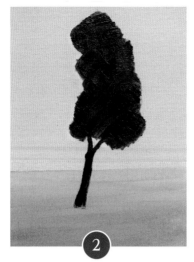
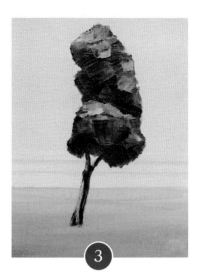

Start with a canvas board and paint a simple landscape as a backdrop. Mix French ultramarine with titanium white for the sky. Apply the paint from the top of the canvas to the bottom with horizontal brushstrokes, gradually adding more white and blending the paint as you go. For the grass, mix French ultramarine with lemon yellow and apply it with large, horizontal strokes. Work upwards, adding more lemon yellow as you go. You don't have to leave this to dry, but it is easier if you do so before drawing on it.

Draw the outline of your tree in pencil without putting in any detail.

On your palette, mix French ultramarine with a small amount of burnt umber to make a dark, bluish black. Paint the tree in silhouette, using your outline as a guide. Apply the paint thickly, using large brushstrokes to add texture. Most of this will be painted over, but vary the direction of your brushstrokes to help create a sense of texture and form from the outset.

While the dark paint is still wet, load your brush with a good amount of lemon yellow. Apply the paint to the foliage area with short vertical and diagonal brushstrokes without reloading your brush, starting in the places that light strikes the foliage: this way you get the rawer, lighter colour where you want it. As you work, the paint will start to blend into a dark green. Keep building up the clumps of foliage, adding more yellow paint as needed, while leaving the shadow areas dark. Clean your brush.

Mix a small amount of titanium white with burnt sienna to make a soft pink, then paint this onto the light side of the trunk. The dark, blue-black base colour will mix with it slightly, adding subtle variations in colour, which will create the look of bark.

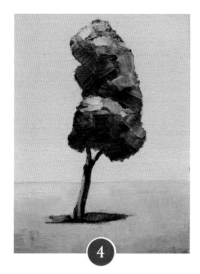

Now develop the texture of the grass. Use short, choppy, vertical brushstrokes without thinning your paint.

Paint the shadow underneath the tree, using the dark mix of French ultramarine and burnt umber from before; it will blend and merge slightly with the grass colour underneath, giving it a more convincing shadow.

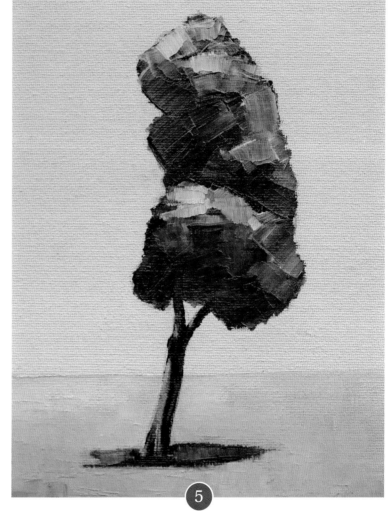

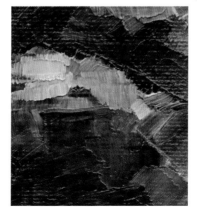

---- NOTE ----

Use the direction of the brushstrokes to describe the shape of the foliage.

In the final stage, keep developing the lights and darks. Rather than painting individual leaves, use the shapes and blocks of different tones to create the form of the foliage. Cézanne's great skill was to find the underlying shapes of his subject.

André Derain: Creating textures and greens in nature

In this exercise, we are going to look at mixing the range of different greens needed to create an effective and varied landscape like André Derain's. We will also examine Derain's technique of applying oil paint to canvas to suggest realistic texture.

RECOMMENDED PALETTE
- ○ Titanium white
- ● French ultramarine
- Lemon yellow
- Cadmium yellow
- Naples yellow
- Yellow ochre
- Burnt umber
- Burnt sienna
- Cadmium red

YOU WILL ALSO NEED
Primed canvas
Flat and round brushes
A solvent
Rags/paper towels

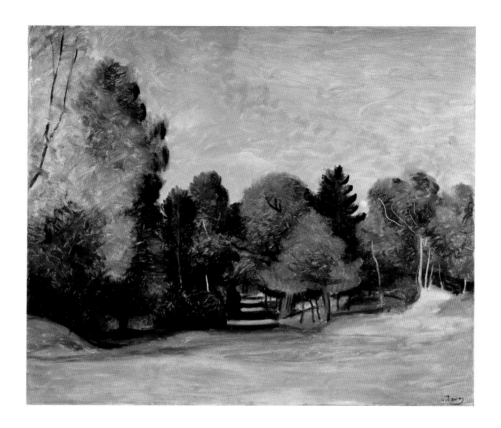

It's a simple scene: a sunny path striped with shadow leads off from a bright, sun-parched grassy area. Tightly packed trees blur in the summer breeze, beneath a blue sky mottled with clouds.

There is a wonderful freedom of expression in this painting, all made possible by the versatility of oil paint. Derain demonstrates its aptness for outdoor work: colours are laid down quickly with paint thinned with turpentine, then adapted, blended and manoeuvred. Derain painted this whole scene, including the sky, with short, slightly scruffy brushstrokes that help to give it a feeling of softness. The trees are the focus of this painting, and Derain has brilliantly captured the variety of their shapes and textures. He created a symphony of green; from the bright, acid, yellowish green to the bluish grey-green leaves that seem to shimmer in the sunlight. He did all this with the swiftness and immediacy required when working outside, directly from nature.

Landscape
near Barbizon
c.1922

—

André Derain
oil on canvas

After the First World War, Derain moved away from the thick paint and bright, unnatural colours for which he had been known and turned to more naturalistic landscapes painted *en plein air*. His palette and brushwork changed, guided by his admiration of realist painters like Jean-François Millet and Jean-Baptiste-Camille Corot, who had painted in these woods around Barbizon 70 years before.

MIXING GREENS

To create a vivid forest green, mix cadmium yellow with a small amount of French ultramarine. For more acid greens, use lemon yellow instead of cadmium yellow. Be wary of adding white to lighten these greens, as this can make them chalky. A yellow (with just a touch of white) will lighten your green without losing intensity.

For dark greens, start with a blue and then add only a small amount of yellow. French ultramarine with yellow ochre will give you a rich, oily-looking green.

For blue-greens, use a small amount of brown (either burnt umber or burnt sienna) with French ultramarine to make a blue-grey colour and then add a yellow to that. Adding Naples yellow will give you a shimmering, blue-grey green, and using cadmium yellow will give you a spruce-like green. These colours can be lightened more readily with white. The most crucial thing with mixing greens is to experiment.

TUBE GREEN VS MIX-YOUR-OWN GREEN

You can buy ready-mixed greens and there is nothing wrong with using them – Claude Monet, for example, used ready-mixed greens that he would adapt – but there are some dangers. One is that if you don't use anything else, the greens in your painting can look uninteresting and lacking in variety. Mixing your own greens gives you an infinite variety of shades to mimic the subtle changes seen in nature.

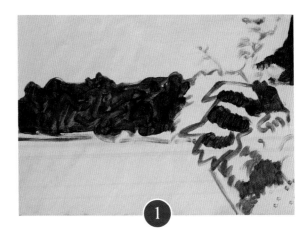

Start by applying a ground colour to the canvas. Derain didn't do this, but he did scratch back into his painting to reveal the canvas (for trunks and branches). In my painting, I wanted to have yellow coming through, to delineate the bricks in the wall and areas of the foliage. For this, I used a thinned-down cadmium yellow.

Using a slightly thinned French ultramarine, paint the outline of the foliage area and the key shapes, keeping them bold and simple. Loosely and quickly, block in the dark shadows.

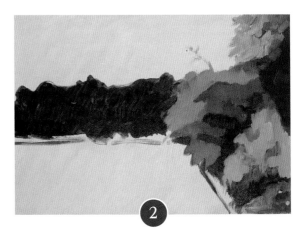

Mix a range of greens with different shades of each. Thin down your paint and start to block in the foliage, starting with the darkest shades and working up to the lightest. Concentrate on the shapes of the bushes, but don't worry about adding detail yet.

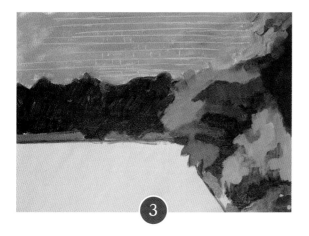

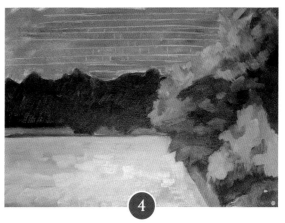

Block in the background so that you can build up greens in the foreground directly on top. For my background, I chose a brick wall. I used cadmium red mixed with burnt sienna, then scratched the paint with the tip of the brush handle to create the separate brick shapes by revealing the yellow ground underneath.

With thicker paint, build up the foliage, using quick feathery brushstrokes and whatever green mixes are appropriate. The key here is just to work quickly – there is no 'right' or 'wrong' brushstroke. Blend colours where necessary, but keep the contrast between the dark blue-greens and the zingy yellow-greens. A scene like this relies on the contrast between light and dark to give it depth.

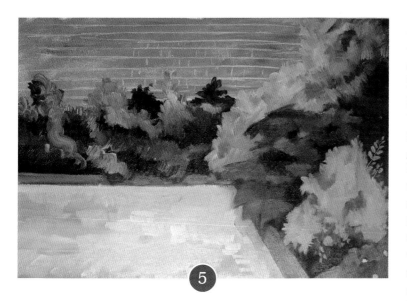

Keep building up the greens to develop the shapes of your foliage and leaves. You can paint a few individual leaves, but don't try to paint every single one, as this will take far too long. When you're painting something like foliage *en plein air*, you want to suggest the leaves rather than try to describe them all exactly. In this final stage, add any shadows cast under the foliage as well and any other final touches. It is important to know when to stop as you don't want to overwork your painting. Look again at Derain's painting and see how he kept the freshness of the landscape by not smoothing out all of his brushstrokes.

John Singer Sargent: Painting *alla prima*

In this exercise, we are going to paint drapery using John Singer Sargent's style of expressive brushstrokes. Work *alla prima*, completing the painting in one go, while the paint is still wet, blending the paint on the canvas rather than the palette. Build the paint up and then, like Sargent, use thicker impasto paint for the highlights.

RECOMMENDED PALETTE
- ○ Titanium white
- ● French ultramarine
- ● Prussian blue
- ○ Naples yellow
- ● Yellow ochre
- ● Burnt umber
- ● Burnt sienna
- ● Alizarin crimson

YOU WILL ALSO NEED
Primed canvas
Flat and round brushes
A solvent
Rags/paper towels

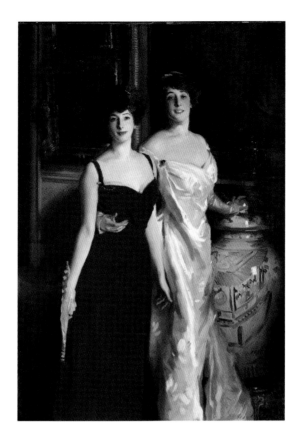

Two sisters stand together, smiling. Betty, in the red dress, looks almost luminous against the darkness of the room. She seems demure, nervous even, her left hand seeking out her sister for reassurance. In contrast, Ena radiates confidence. She shines off the canvas in her shimmering, white damask dress, her arm wrapping around her sister's waist.

Sargent was friends with the prominent art dealer Asher Wertheimer, and this portrait of his two daughters reveals a genuine affection for the family. There is a wonderful energy and liveliness to Sargent's brushstrokes that breathes life into his subjects.

Ena and Betty, Daughters of Asher and Mrs Wertheimer 1901

—

John Singer Sargent oil on canvas

Sargent spent some time in Haarlem, the Netherlands, where he copied works by Velázquez and Frans Hals. His admiration of their swift, expressive brushstrokes helped him develop a similar freshness and immediacy in his own work. In this painting, this is especially apparent in the girls' dresses, where often only a couple of brushstrokes describe the texture and folds of the fabric. Sargent worked *alla prima*, which meant that he worked quickly into the wet paint. This gives the finished painting a loose, almost unfinished feel when it's looked at closely – but step back and the painting shines.

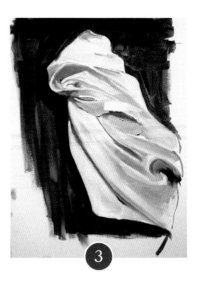

Mix French ultramarine with burnt sienna and thin it down with a solvent. Using this mix, loosely draw the outline of your piece of fabric with a small flat brush. Don't worry about getting the outline exactly right or putting in detail at this point.

Mix a dark purple from French ultramarine and alizarin crimson. Using a large flat brush, roughly block in the background, adding more French ultramarine on the top half and more alizarin on the bottom half.

On your palette, squeeze out a generous amount of titanium white, and, next to it, mix burnt sienna with an equal amount of French ultramarine. Add a tiny amount of this colour to the white to create a light grey. Do not thin your paint at this stage.

Start building the surface of the fabric by blocking in the warm and cool shades, adding more burnt sienna to the grey for warm tones, and more French ultramarine for cool tones. Use a broad flat brush and work quickly and loosely, letting your brushstrokes follow the curves and contours of the fabric.

Start to build up the shadows in the background with a dark mix of Prussian blue, burnt umber and alizarin crimson.

NOTE

Oil paint is the perfect medium for working *alla prima*, especially when it comes to drapery. The wet paint can be moved and blended on the canvas to perfectly describe the curves and folds within the fabric.

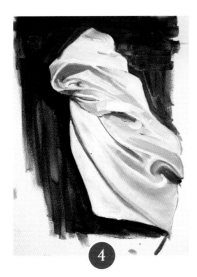

4

Develop the highlights and the darkest shadows within the fabric. For the darkest areas, use a mix of French ultramarine, alizarin crimson and burnt sienna. Alizarin crimson can make things slightly pink as it blends with lighter tones, so don't use too much. Apply the highlights with thick, white paint, adding a tiny bit of yellow ochre and Naples yellow to some of the warmer highlights.

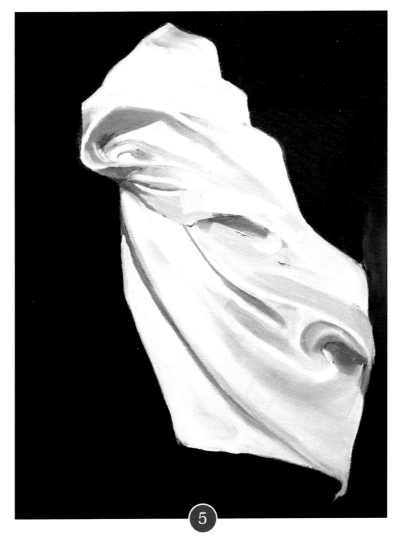

5

Block in the background, using a dark mix from Step 3 to make your fabric stand out. Touch in the last little areas of highlights on the fabric, but do not overwork them – you want to keep the painting fresh. As in Sargent's work, there is nothing wrong with seeing the brushstrokes.

Walter Sickert: Creating form and drama using unblended brushstrokes

This is an exercise in painting the human form, using directional brushstrokes and dark shadows to create a dramatic contrast. Find a dark room with a strong light source so that, as in Walter Sickert's painting, your subject is predominantly obscured by shadow.

RECOMMENDED PALETTE
- ○ Titanium white
- ● Prussian blue
- ● Naples yellow
- ● Yellow ochre
- ● Burnt umber
- ● Burnt sienna

YOU WILL ALSO NEED
Primed canvas
Flat and round brushes
A solvent
Rags/paper towels

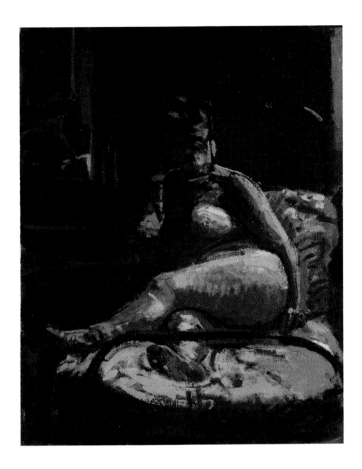

We stand, like voyeurs, at the foot of a cheap iron bedstead and look down at a naked woman. The murky light, coming from some source beyond the picture frame, picks out odd fragmented forms. Sickert accentuated the highlights with rough, broken brushstrokes, building them up on top of each other. There was no blending or polish to his handling of the paint, just thick impasto marks, with everything treated in the same, unforgiving way.

Sickert deliberately made this painting ambiguous. The identity of the woman is unknown, the place is shrouded in darkness and our position as viewer is murky. Even the title, *La Hollandaise ('Dutch Girl')*, leaves us with more questions than answers.

The woman's pose is awkward and clumsy as she lifts herself up from the crumpled sheets. Her reaction is invisible as her face is obscured by the dark shadow that swamps the rest of the room. This gritty painting has the feel of a macabre thriller and is just as enthralling.

La Hollandaise
c.1906
—
Walter Sickert
oil on canvas

Start with a coloured ground. For mine, I mixed a blue-grey from Prussian blue, burnt umber and titanium white, thinned down with a solvent. This will take a day or two to dry. It gives you a cool mid-tone on which you can build up the lights and darks that will form the body. The coloured ground also gives you a mid-tone to start on, so you don't have to contend with the extreme contrast of painting a very dark subject on a white ground. This makes it easier to judge the relative tones within the subject.

Mix Prussian blue and burnt umber to create an incredibly dark, treacly black, then block in the dark background. Thin this colour down and block in the main areas of shadow on the figure, then add more solvent to thin the mix down even more and lighten the colour for the mid-tones.

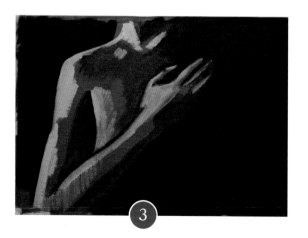

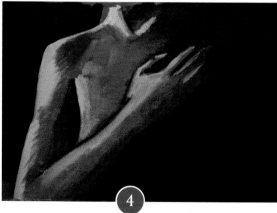

Look for the patches and shapes of light on your subject and block them in with a thinned-down titanium white. At this point, the blue-grey ground colour will still be visible in places.

Mix a warmer flesh colour with titanium white and small amounts of burnt sienna and yellow ochre. Use a round brush or the sharp edge of a flat brush to block in the warmer flesh areas – these will be the areas caught in the light. Use Naples yellow for highlights.

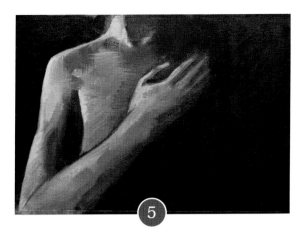

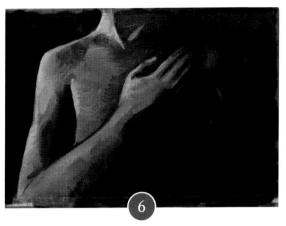

Build up the body with slash-like brushstrokes, like hatching marks in drawing. Don't try to hide these brushstrokes – keep them all visible.

Finally, darken the darkest shadows on the body by working over the initial painted layer. Use a hatching brushstroke if there is a transition from a dark area to a lighter one, as this helps to describe the form. Pick out any highlights using a slightly thicker mix of titanium white than before.

> **NOTE**
>
> The blue-grey ground gives a cool, murky, almost cadaverous feel to the body, as in Sickert's painting. If you want a warmer feeling, with the lighter tones having more impact, paint on a warm ground such as burnt sienna.

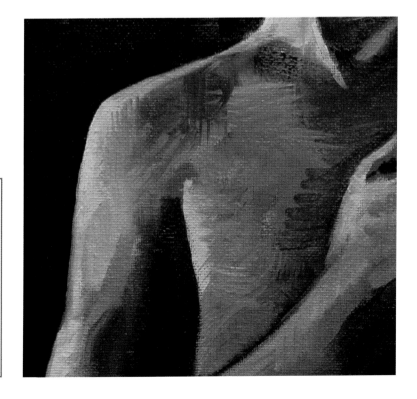

Lucian Freud: Creating flesh tones by working with impasto paint

Lucian Freud painted people in a way that makes you feel as though you can reach out and touch them. The key to this exercise is building up the surface of the painting by applying the paint in thick strokes to define the different planes of the face, then smoothing out the paint to create subtle transitions between light and dark. I recommend painting an older relative; my painting is of my dad, and I have chosen a similar viewpoint to Freud's portrait of his mother.

RECOMMENDED PALETTE
- Titanium white*
- French ultramarine
- Yellow ochre
- Burnt umber
- Burnt sienna
- Alizarin crimson

(*Freud used cremnitz white for its thick consistency, but titanium white works fine.)

YOU WILL ALSO NEED
Primed canvas
Charcoal
Flat brushes
A solvent
Rags/paper towels

The dominating feature in Freud's depiction of his mother, Lucie, is her skin – the ruddy, unglamorous portrayal of her face. Freud's early work was sharp and tight, done with thinned-down paint, but later, as we see here, he moved into using paint much more thickly, building up layers. His thick application of paint captures the weight and physicality of his mother's face. The slight sag of her cheeks and fleshiness of her nose are all painted with an unflinching honesty.

The Painter's
Mother IV
1973
—
Lucian Freud
oil on canvas

There is a unity to Freud's colour palette: browns, greys and reds are the main colours, in the face as well as in the clothes, hair and background. Close up, you can see distinct areas of reds and bluish greys that seem exaggerated, but step back and they all work as a coherent whole.

The portrait is small (27.3 × 18.6cm/10½ × 7 ½in) and intimate in size, unlike some of his later paintings.

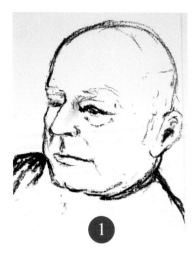

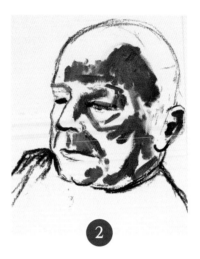

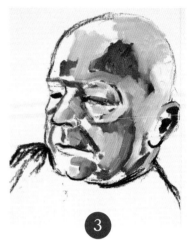

Using charcoal, draw the outline of your subject. Be aware that, when you start painting, the charcoal will mix with the paint, making it slightly blue.

Mix burnt sienna, a little alizarin crimson and burnt umber to make a dark red. Using a medium-sized flat brush – which will give you broad, slab-like brushstrokes – loosely block in the warm shadows. Let the direction of your brushstrokes form the planes of the face. Add French ultramarine to this mix to make a dark blue for the cool shadows. Thin this paint down slightly with a solvent, just enough to give it a little more fluidity, and block in the cooler shadows.

Block in some mid-tone colours, again, distinguishing between warm and cool. For the warm tones, mix titanium white with burnt sienna and a tiny bit of yellow ochre (you can add a little bit of French ultramarine to stop this colour becoming too pink. It will make it slightly grey, but that's okay). In my painting, the area around the mouth and chin was distinctly cooler: if that's the case, block in a bluer mid-tone.

NOTE

Shadows aren't just black, they have colours in them. Cooler shadows are bluish, and warm shadows have a reddish hue. The colour of the shadows will often depend on the light source producing them: natural light usually produces a cool, blue tint, while artificial light is redder and warmer. By using different colours instead of black, you will be able to create more realistic skin tones.

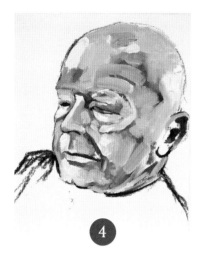

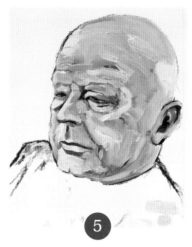

4

Now work on the lighter areas. For these, mix a small amount of yellow ochre with titanium white. This will give you a punchy yellow, so you might want to temper it with a small dab of the dark red colour you used previously. Loosely block in these light areas and fill any areas you might have overlooked. At this point, the whole face should be covered.

5

Working with slabby brushstrokes means that at this point, your portrait might look slightly tessellated. Refine your portrait by building on top of the paint that you've already laid down, using the same mixes as before. Don't thin and smooth over the paint too much: you still want to feel the sticky, buttery consistency of the paint as you build it up, especially around the eyes. Work confidently, with definite, visible brush marks. The purples, greens and blues will all combine to make a convincing depiction of skin and flesh.

6

Block in the shirt, using darker tones for the creases in the fabric to give it some form. Use the colours you have on your palette to mix a dull, greenish grey for the background. This colour will contrast well against the reddish colours of your subject's face, making it stand out. Like Freud, you can use a lighter grey for the top section of the painting. Finally, make any adjustments to the colours on the face, without overworking it.

NOTE

All the time you are blocking in the colour, keep assessing and adjusting the underlying structure of your subject. Don't take the initial drawing as final.

John Everett Millais: Using an oil medium to create smooth, realistic modelling

In this exercise, like John Everett Millais, you will be working with an oil medium to help blend and smooth your paint, and building up layers to give your painting depth. We will be paying particular attention to working fat over lean, where thin layers of paint are applied before thicker layers.

RECOMMENDED PALETTE
- ○ Titanium white
- ● French ultramarine
- ○ Cadmium yellow
- ● Yellow ochre
- ● Burnt umber
- ● Burnt sienna
- ● Alizarin crimson

YOU WILL ALSO NEED
Primed canvas
Flat and round brushes
An oil
A solvent
Rags/paper towels

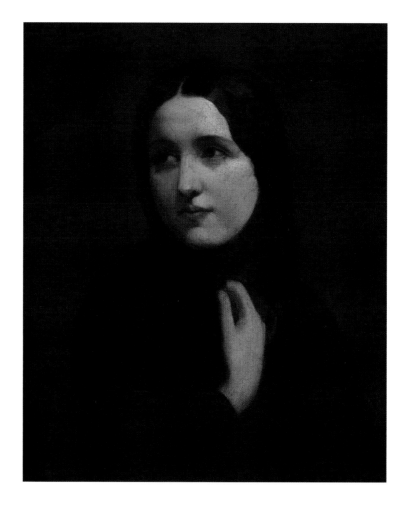

In this painting, we see a girl turning her head from us – a classic pose of demure modesty. Her face is radiant, framed by her dark hair and scarf, set against a dark background. Little is known about Miss Anne Ryan; Millais said in a letter that her beauty 'proved a fatal gift'. It's an intriguing mystery, and this painting captures her alluring charm.

Millais co-founded the Pre-Raphaelite Brotherhood in 1848 that championed the idea of realism in painting. His themes, both early and late in his career, were usually literary, historical or religious, with friends and family posing as various characters. What is interesting with this work, is that Millais paints Miss Ryan as herself.

The warm luminescence of Miss Ryan's skin is one of the stand-out aspects of this painting. To achieve this, Millais works with oil medium to create translucent glazes of colour. This helps capture the soft shift from light to dark that describes the delicate form and contours of her face.

Miss Anne Ryan
undated
——
John Everett Millais
oil on canvas

Mix a dark blue-black from burnt sienna and French ultramarine. Thin it with a solvent and paint the outline of your portrait, keeping your brushstrokes loose but making sure you place the features accurately.

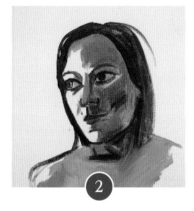

Starting with the shadowed areas, roughly paint the form of the face. Mix burnt sienna with small amounts of burnt umber and alizarin crimson to create a dark, reddish brown. Thin this mix down and paint the side of the face that is in shadow. For cooler shadow areas, add a small amount of French ultramarine and a tiny bit of titanium white.

Now mix titanium white with a tiny bit of yellow ochre, and block in the lighter areas. Look for the shapes that the light makes.

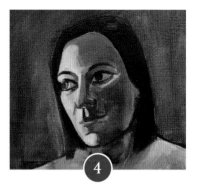

Thin down a good amount of burnt sienna, and loosely block in the background.

Develop the shadow areas, working on top of your underpainting. Mix burnt sienna with titanium white, then add a small amount of French ultramarine to give a dark mid-tone. Don't thin your paint now. Use a flat brush for the bigger areas and a round brush for details. Within the shadows, there are more darks and lights, some cooler and some warmer; these can all be made by adapting the mid-tone you have just mixed. I added more burnt sienna and alizarin crimson for the area under the cheek, and added burnt umber and French ultramarine to darken it further for the area between the eyes and the nose. As you develop the tones, keep working on shaping and advancing the features.

For the eyes, I used cadmium yellow to create the glow where the light catches them.

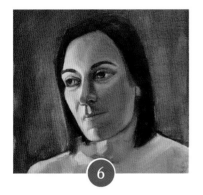

Now that the features and basic areas of light and shade are all in place, build on this using an oil medium mixed with a solvent. In a small pot next to your palette, I recommend mixing some linseed stand oil (it has a thick, honey-like consistency) with a splash of solvent. Mix this with paint and then apply it over the previous layer. This might feel sticky at first, but it will smooth over your brushstrokes and give a much easier blend from dark to light, which is perfect for the surface of the skin.

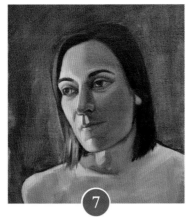

Add the highlights, such as small touches of pure white on the eyes to make them shine. With a flat brush, mix a small amount of yellow ochre with titanium white and a tiny amount of burnt sienna, and paint over the top of the dark hair colour, following the natural direction of the hair. For the highlights on the hair, mix titanium white with a tiny amount of yellow ochre and apply with a small round brush.

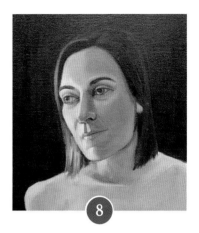

Mix a dark brown-black French ultramarine, burnt umber and a little yellow ochre, and paint the background with a large flat brush. Lighten this slightly with titanium white and a touch of yellow ochre around the head, to give a subtle glow like Millais does.

NOTE

Millais and the other Pre-Raphaelite Brotherhood members painted on a white ground, as opposed to the coloured ground that was the more traditional practice for painting, especially for portraiture. They believed that the white background kept the colours brighter.

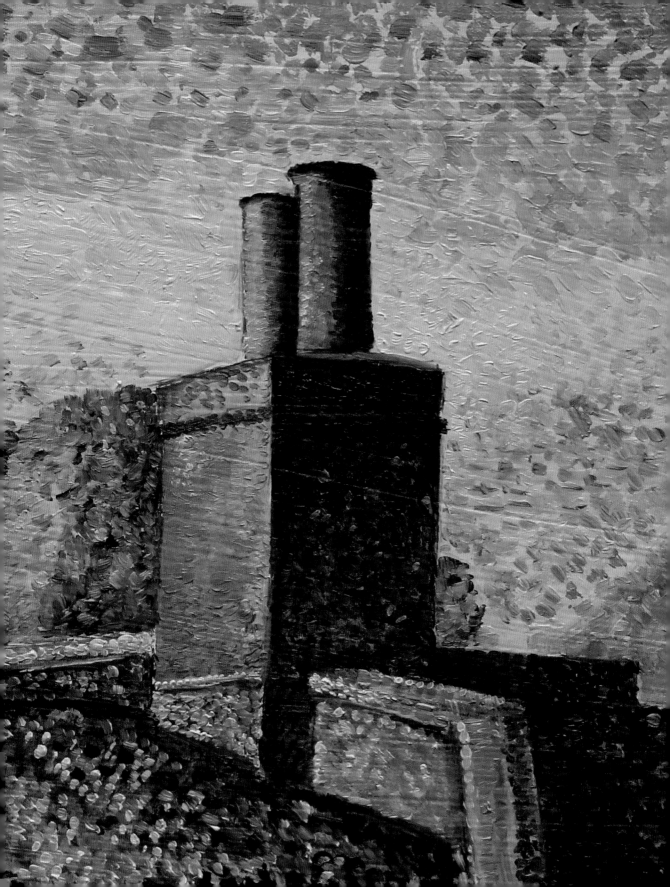

Colours
& Mixing

David Cox: Creating a range of greys

In this exercise, you will be painting a cloudy sky directly from observation. Like David Cox, you'll need to work quickly to capture a constantly shifting cloudscape. Work on paper, mixing paint on the paper as well as on the palette. Look closely to observe the different shades of grey that make up the clouds: there will be cool, bluish greys as well as warm, pinkish greys. This is a sketch, so don't worry about it looking slightly scruffy.

RECOMMENDED PALETTE
- ○ Titanium white
- ● French ultramarine
- ● Burnt sienna

YOU WILL ALSO NEED
Paper
PVA glue
Flat and round brushes
A solvent
Rags/paper towels

This small (16.5 × 23.8cm/6½ × 9½in) sketch brilliantly captures a fleeting moment. The sun breaks through grey clouds as they scud across the sky.

Cox built up layers of bluish-grey paint on top of brown paper. He used his fingers as well as his brush to get the effects he wanted; smudging or dragging the paint, often leaving patches of the paper's reddish-brown colour showing through. Dark tones contrast with the thick white paint, with flecks of pale blue applied last to give the effect of the bright sunlight breaking through.

In the nineteenth century, artists in Europe and England began to move away from an idealised and formulaic landscape, observing nature directly and painting its richness of colour and light. Cox loved the everyday English sky and painted it in a variety of different conditions. Even on the greyest of days, he saw the subtle hues of pinks and blues in the grey clouds.

**Clouds
1857**

—

**David Cox
oil on paper**

MIXING GREY

On your palette, mix French ultramarine and burnt sienna to make a dark colour. Nearby, spread out a large amount of titanium white. Add small amounts of the dark colour to the white to make different shades of grey. To make the grey pinkish and warmer, add burnt sienna to the mix; and to make it cooler, add French ultramarine. On your palette, create a spectrum of dark to light, for both warm and cool shades.

Mix a small amount of French ultramarine with a large amount of titanium white. Take this light blue and block in anywhere you can see blue sky. Remember that the sky changes every second – so be prepared to adapt as you go.

I started with the light, wispy clouds in the background, which are a very pale grey. In many skies, the faintest clouds will fade into the blue sky, so let the light grey blend into the blue that you've already laid down.

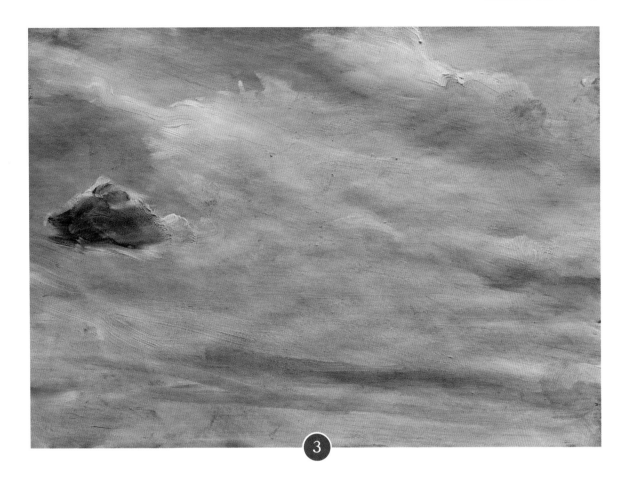

3

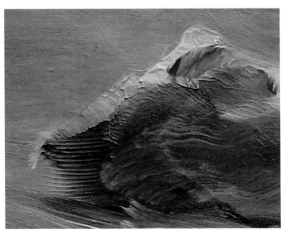

For darker clouds, apply the dark grey mix that you have mixed on your palette to the still-wet paint of your sky, applying it thickly, with a broad flat brush. Look for the warmer and cooler shades of grey and adjust your paint mix accordingly. Let the way you move the brush define the volume of the cloud. With a thinner brush, introduce pure white around any dark clouds to suggest backlighting. Look carefully to see where the edge of this white outline sits in direct contrast to the dark grey, and where it blends into it.

Georges Seurat: Optical mixing

This is an exercise in pointillism, using pure colours in small dots and dashes that blend together in the eye, rather than on the canvas. Georges Seurat made small pointillist paintings on the spot, which he then used in the studio as a reference for more precise and painstakingly detailed paintings. Your painting can be small in scale, but by using photographic reference combined with observation, you can be detailed as well. I picked a subject that I can see out of my window, as the chimney gives a strong central motif, like Seurat's rocky outcrop.

RECOMMENDED PALETTE
- Titanium white
- French ultramarine
- Cerulean blue
- Cadmium yellow
- Yellow ochre
- Burnt umber
- Burnt sienna
- Alizarin crimson
- Cadmium red

YOU WILL ALSO NEED
Plyboard
Acrylic gesso primer
Fine-grit sandpaper (optional)
HB pencil
Round brushes that can be
 shaped to a point
A solvent
Rags/paper towels

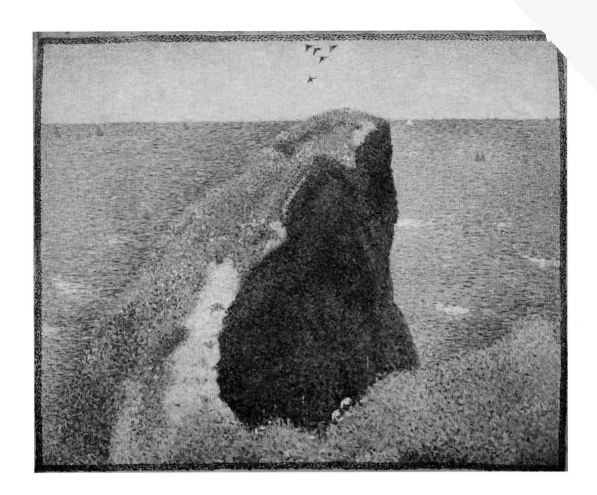

The striking rocky outcrop in the middle of this composition dominates. The intense sunlight casts a deep purple shadow on its craggy rock face, and behind it, high up the canvas, the turquoise sea glows and shimmers as it meets the bright summer sky. This view of the coast of Normandy became a popular subject for Seurat, who saw it first in 1885 when he was on holiday there.

Seurat was a pioneer of pointillism (or divisionism). This took the fundamentals of Impressionism – colour and light – and combined them with scientific principles that moved their paintings into a less spontaneous, more considered style of painting. Seurat, and other pointillists, studied and developed the science of colour theory. The key was that they didn't mix their paints on their palette but would apply small dabs or dots of raw, unmixed colour directly to the canvas. These colours were mixed as the viewer looked at the work, the theory being that a blue dot next to a yellow dot would combine 'optically' to make green in the viewer's eye.

Le Bec du Hoc, Grandcamp 1885

—

Georges Seurat
oil on canvas

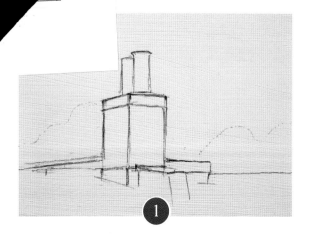

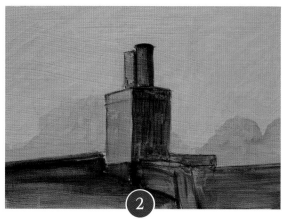

Prime your board with acrylic gesso and leave it to dry. Sand it to a smooth finish, if you wish. With a pencil, draw your subject, positioning it in the middle of the board. Keep it simple and don't draw it too small.

Thin your paints with a solvent, and very loosely block in the basic colours. Here, I mixed a light blue from cerulean blue and titanium white, and a light green from a small amount of cerulean blue mixed with cadmium yellow. For the chimney, I thinned down burnt sienna, and for the roof, I mixed French ultramarine with a small amount of burnt sienna.

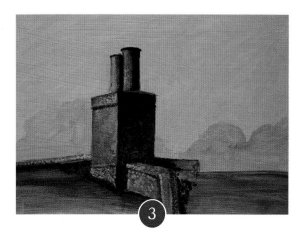

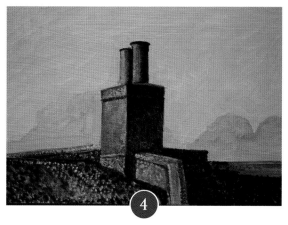

Start with the shadows on your central subject and paint in dabs of the darker colours. Use the same colours you would normally mix together on the palette, but instead, place dots of the unmixed colours next to each other. Here, I applied burnt sienna, burnt umber and alizarin crimson for the shaded side of the chimney, and burnt sienna, cadmium red, yellow ochre and titanium white for the lighter areas. Try to keep your dots as definite and distinct as you can.

Continue to fill in the foreground with dots. I developed the shadow on the rooftop with French ultramarine, burnt umber and alizarin crimson, and I used lighter cerulean blue and dots of titanium white for lighter areas.

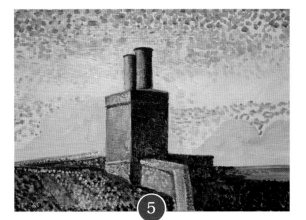

5

For the sky, use larger dots and marks, especially at the top of the board. This area of the sky is closer to us, as it's directly overhead, while towards the horizon it is farther away, so varying the size of the dots helps to create a sense of distance – as well as speeding up the painting process. Use French ultramarine at the top, and cerulean blue with dots of titanium white for paler areas of sky. In my painting, the bottom of the sky is red, like an evening sky. For this, I used cadmium red, which will really stand out against the green of the trees, as red and green are complementary colours.

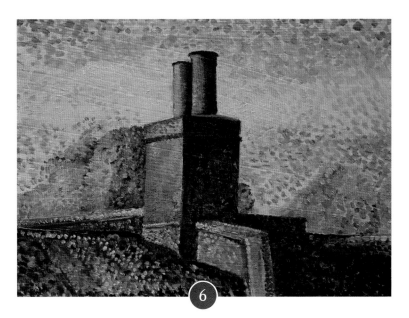

6

Develop your middle ground. In my painting, I mixed cadmium yellow with a small amount of French ultramarine to make a bright, intense green. Start with the dark areas: I used mainly French ultramarine with just a few dots of green for the darker tree areas. To create a softer, more muted tone for the trees in the distance, I mixed the green and the blues with white.

Finally, I added tiny dots of the green to the chimney. As red and green are complementary colours, this makes the red seem more intense and vivid.

Stanley Spencer: Using a dominant colour to unify a painting

Using Stanley Spencer's wonderfully warm painting as inspiration in this exercise, we are going to create a scene that is unified by colour. This technique can be transferred to any subject matter, but I chose an interior because the curve of the stairs could be exaggerated to emulate the curve of the bridge, and the light had a similar quality to the dreamlike mood in Spencer's painting.

RECOMMENDED PALETTE

- ○ Titanium white
- ● French ultramarine
- ○ Cadmium yellow
- ● Yellow ochre
- ● Burnt sienna

YOU WILL ALSO NEED

Primed canvas
HB pencil
Flat and round brushes
A solvent
Rags/paper towels

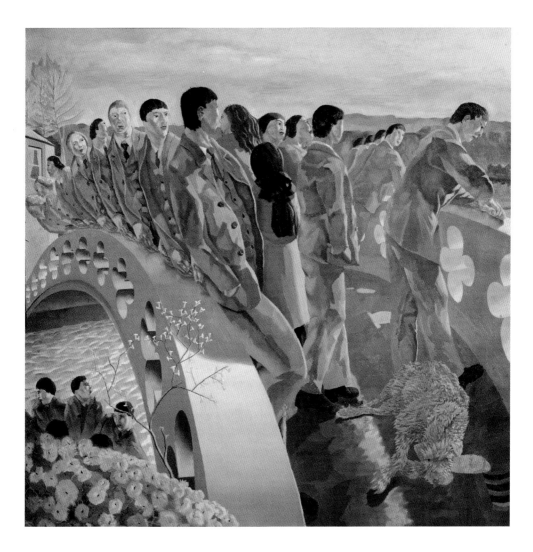

The most striking element of this dreamlike painting is its overall buttery colour: the water, bridge, clothes and sky all glow with a soft, honey-coloured light. The painted surface switches subtly from a smooth gradation, as on the rail of the bridge, to the more textured paint in the clothes and roadway.

From the beautiful sweeping curve of the bridge to the rippled surface of the river, Spencer's handling of the paint creates a wonderful harmony – not only in colour but also in the tactile quality of the painted surface. This unity aids Spencer as he beautifully blends the imagined and the real.

Cookham (Berkshire, England) was the setting for many of his large-scale (approx. 120 × 120cm/50 × 50in) paintings, which often have religious themes and tell biblical stories. The narrative in this painting is more ambiguous: the people here could be watching the Cookham regatta.

**The Bridge
1920**

—

**Stanley Spencer
oil on canvas**

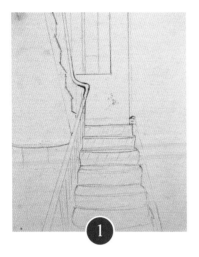

Draw an outline of your chosen scene on your canvas in pencil.

Loosely block in the whole scene. This is the 'dark' stage; you will bring the lighter tones in later. The key colours are burnt sienna and yellow ochre. In my painting, I mixed in a tiny bit of French ultramarine for the wall on the right and for the darker area around the window. Even though there is colour harmony, you still need some contrast to get a sense of light. At this stage, your brushstrokes can be loose and your paint thinned.

Now develop the colours and the lighter areas. Don't thin your paint for this stage – use the thick stickiness of the oil paint to build up rich tones. For areas of gradation, I worked from titanium white and yellow ochre through to pure yellow ochre and burnt sienna, without introducing dramatic contrast. For the lightest areas, I mixed a small amount of yellow ochre and cadmium yellow to titanium white. For the highlights, use a round brush as this helps avoid harsh edges when you're blending, which means they won't stand out in a way that looks unnatural.

NOTE

To keep the colours and tones harmonious, work across the whole painting at the same time. I used the same colours for the wall on the right as I did on the underside of the stairs on the left.

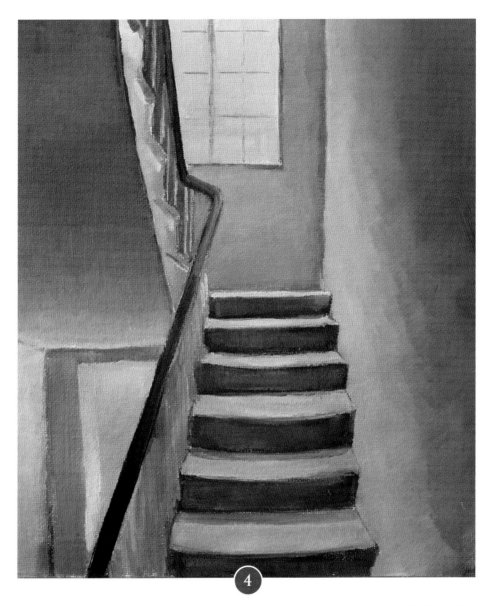

4

For the final stage, bring in small details such as the banister, rails and window frame in my painting. Step back from your painting and make sure that the whole piece works together before making any final adjustments.

J.M.W. Turner: Creating a sense of atmosphere, dawn or dusk

J.M.W. Turner used a variety of techniques to create the feeling of atmosphere. He would thin his paint with turpentine, letting the white canvas shine through to give the paint a luminosity, or paint impasto streaks of bright colour to give the effect of light striking a surface. This helped him capture the light effects and the mood of a scene or view, which is what we'll be doing in this exercise. The view I have used is of Battersea Power Station, by the River Thames in London.

RECOMMENDED PALETTE

- Titanium white
- French ultramarine
- Cadmium yellow
- Naples yellow
- Burnt umber
- Burnt sienna
- Alizarin crimson

YOU WILL ALSO NEED

Primed canvas
Flat brushes
Palette knife
A solvent
Rags/paper towels

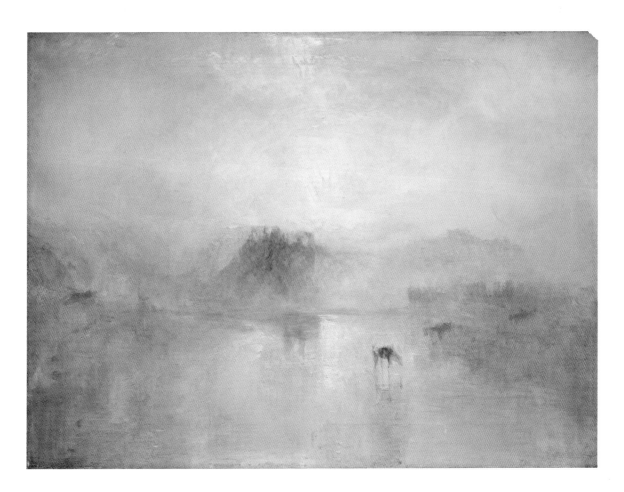

This painting shows the ruins of Norham Castle on the banks of the River Tweed in Northumberland, England. The castle seems to hover between sky and land as they blur together in a haze of pinks and blues. The whole scene shimmers, as the bright, blazing sun dissolves the landscape.

This was a landscape that Turner knew well. He had painted watercolours of these ruins years before he made this painting, which may have contributed to the airy, fluid feel of this piece. It was painted right at the end of his life and was never exhibited. He may have painted it to test the market, to see if collectors would buy a painting as unusual as this, or it could have been purely for himself, to save and savour a place and a moment.

This painting isn't just about depicting a place realistically– it's about capturing the feeling of it. The light and atmosphere of the place is the main focus, not the specific details.

Norham
Castle, Sunrise
c.1845

———

J.M.W. Turner
oil on canvas

1

Mix a large amount of light blue from French ultramarine and titanium white, and loosely paint in a faint horizon, leaving some blank areas in the centre of the foreground, where the light hits the water most strongly.

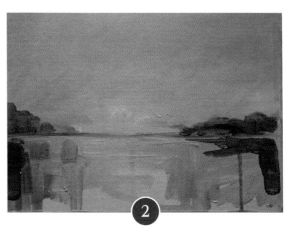

2

Thin down burnt sienna and roughly block in the land with a broad flat brush. Don't worry if the thinned paint runs.

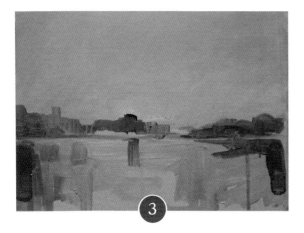

3

Working on top of the pale blue sky, build up the forms of the landscape, using French ultramarine and burnt sienna with a broad flat brush. Let these colours blur and smudge into the wet sky.

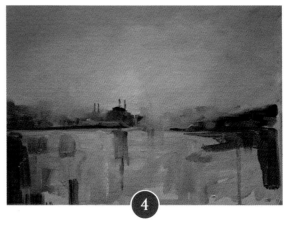

4

Mix alizarin crimson and burnt sienna with titanium white to make a pinkish red, and blend it into the sky, using short, feathery brushstrokes to give it texture. Mix cadmium yellow with titanium white and blend this into the centre of the sky, making the yellow more concentrated at the brightest area; don't thin the paint as much at this point, but use the thicker consistency of the paint to build up the surface of the painting. Drag the colours of the sky into the water, being vigorous and free with your brushstrokes. Bring some darker burnt umber into the sides of the painting.

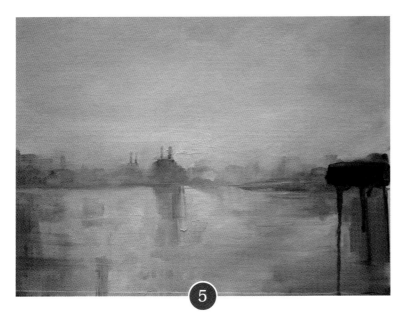

Continue to build up the surface of your painting, thinning the paint and allowing it to drip and run down your painting.

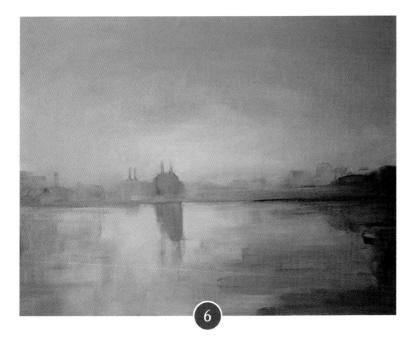

Use a palette knife or similar tool to scrape areas back, or wipe them with a rag or paper towel to lighten areas and let the white of the canvas shine through. For intense, bright highlights, apply titanium white mixed with a tiny amount of cadmium and Naples yellow with an impasto technique.

James Abbott McNeill Whistler: Thinning and blending

In this exercise, we're going to explore the technique of thinning paint down with an oil and solvent. Like James Abbott McNeill Whistler, we will paint an evening sky, looking to blend all our colours to create a realistic, moody sunset and a dark foreground. You will need to work quickly and loosely to keep the landscape looking as fresh and spontaneous as Whistler's.

RECOMMENDED PALETTE
- ○ Titanium white
- ● French ultramarine
- ○ Cadmium yellow
- ● Burnt sienna

YOU WILL ALSO NEED
Primed canvas
Flat brush
A solvent
An oil
Rags/paper towels

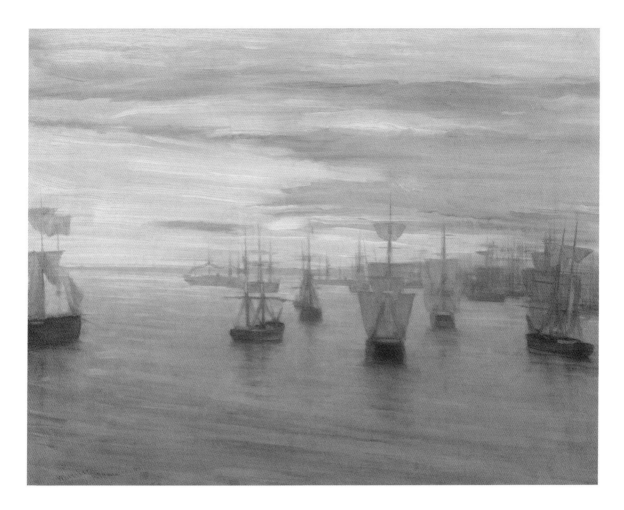

Whistler has created a calming view of ships resting in harbour. The sinking sun lights up the clouds with colours of purple and orange; the evening light blurs the shimmering, green water, and even the ships seem to fade and blur into the seascape.

Whistler was a painter of harmony, both in his landscapes and his portraits. He would often use musical terms to title his work. Whistler saw painting as simply an arrangement of colours on the canvas, but he could still give a subtle narrative. 'Valparaiso' refers specifically to the Chilean harbour that was bombarded by the Spanish in the same year of this painting.

In terms of technique, Whistler was hugely experimental and liked to push the limits of his paint. He would thin his oil paint, using a mixture of turpentine and linseed oil, but he also added other, less traditional substances to his paints to gain the desired luminosity. He said this thinned-down paint was like 'breath on the surface of glass.'

Crepuscule in
Flesh Colour and
Green: Valparaiso
1866
—
James Abbott
McNeill Whistler
oil on canvas

Mix a generous amount of blue for the top, darkest area of your evening sky. Don't be stingy – you need enough to cover at least a quarter of your canvas. Start with titanium white, then add French ultramarine until you get the colour you want. With smooth, horizontal brushstrokes, apply the blue to the top third of your canvas. Clean your brush and then paint titanium white just underneath the blue.

Now blend, starting from the white area at the bottom. Keep your brushstrokes horizontal, taking them right to the edges of the canvas. Slowly and smoothly move up into the blue area. Keep your brushstrokes light to help smooth the gradation. Always keep your brush on the canvas when blending and clean your brush whenever you take it off.

On your palette, mix titanium white with a small amount of burnt sienna to make a pink colour. Apply this under the light blue and blend upwards, with the same smooth horizontal brushstrokes as before, working your way into the pale blue. This will give you a warm, hazy colour.

Now mix a small amount of cadmium yellow and burnt sienna on your palette to make a light, warm orange; this will create the colour for your sunset. You will need to add titanium white to soften the intensity. Apply this under the warm, hazy colour and blend it upwards. If the sunset is too intense, you can blend white directly on the canvas.

With a clean brush, on a clean area of your palette, mix French ultramarine with burnt sienna to create a dark purple. Paint this directly underneath your sky, cutting right into it so there is no white gap.

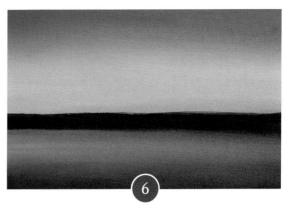

Now place titanium white on your palette and mix it with an equal amount of oil and a small amount of solvent. Blend it into the bottom quarter of the dark colour to create a smooth, soft, watery effect.

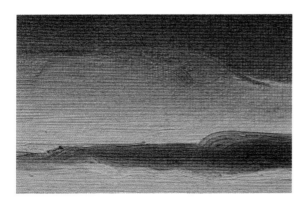

— NOTE —

Have the oil in a small pot next to your solvent. Add a bit of the oil and a small amount of solvent to your paint at each of the stages. This mix of oil and solvent keeps the paint wet, which helps with blending. Don't use too much oil or the pigment will get 'stretched' and not cover the canvas well. It takes some trial and error to find the right consistency.

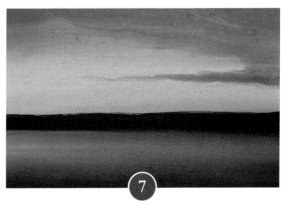

For the clouds, take the dark purple mix from Step 5 and paint it directly onto the sky. The lighter paint on the canvas will naturally start to mix in with the dark colour. Add titanium white to lighten the clouds and small amounts of burnt sienna or French ultramarine to create warmer or cooler colours (not too much, otherwise the colours will become too intense).

Finally, take a smaller brush and, with the light orange mix from Step 4, mixed with some titanium white, pick out patches of light at the bottom of the clouds.

Armand Guillaumin: Complementary colours and colour theory

In this exercise, we are going to explore simple colour theory, using complementary colours to enhance the vibrancy and luminosity of a landscape. The richness and range of colours that oil paint has to offer makes it the perfect medium for exploring colour in nature. Like Armand Guillaumin, I've gone for a view with trees, a stretch of water and a grassy bank, but there are beautiful colours everywhere, even in the city.

RECOMMENDED PALETTE
- ⚪ Titanium white
- ⚫ French ultramarine
- ⚪ Cadmium yellow
- ⚪ Yellow ochre
- ⚫ Burnt sienna
- ⚫ Cadmium red

YOU WILL ALSO NEED
Primed canvas
Flat, filbert and round brushes
A solvent
Rags/paper towels

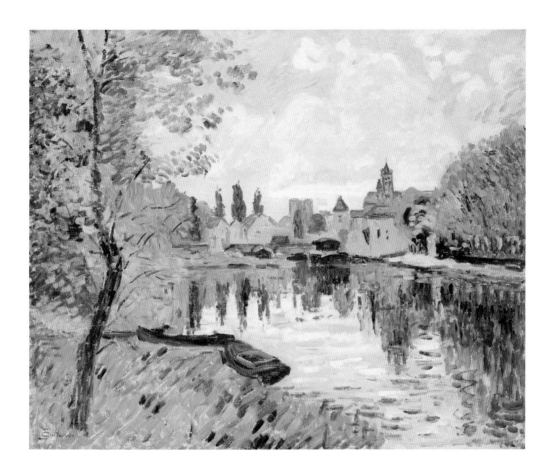

Afternoon sun shines off the surface of the river, filling the landscape with light and colour. A bright red boat is moored against a green bank, and pink and purple houses huddle in the distance, with the bright yellow foliage of a tree shimmering on the left of the painting. All of these elements radiate off the canvas.

The colours in this painting are particularly bright and punchy, and Guillaumin has increased their impact by placing complementary colours next to each other, using choppy dashes and dabs of paint. Complementary colours sit opposite each other on the colour wheel. The three primary colours are red, blue and yellow, and a primary colour's complementary colour is created when the remaining two primary colours are mixed.

So, for example, red's complementary colour is green (yellow mixed with blue). When you put complementary colours next to each other, they appear brighter: just look at Guillaumin's bright red boat right next to his vivid green bank.

Guillaumin painted a number of versions of this view because – like other Impressionists drawn to this beautiful, quiet stretch of the Seine – he was fascinated by the effects of different light and weather conditions on the landscape.

Moret-sur-Loing
1902
—
Armand Guillaumin
oil on canvas

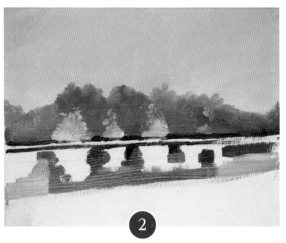

Mix a light blue from titanium white and French ultramarine. With a medium flat brush, block in the sky, applying paint to just below where the treeline will start. Don't put down an outline first – just work straight onto the canvas.

Work on the middle ground – in this case, an autumnal treeline and a river. I mixed a reddish purple from cadmium red and burnt sienna, to which I added French ultramarine before lightening the mix with titanium white. Then, using a filbert brush with short, dabby brushstrokes, I blocked in the trees and their reflection, letting any slight inconsistencies in colour come through. I used cadmium yellow, yellow ochre and a touch of cadmium red to make an intense orange for the brightest trees, accentuated with a complementary pure blue under the tree line to emphasise the river edge. At this stage, we are just establishing our scene. We will build up the colours on top of this.

NOTE

The Impressionists observed and painted the effects of light in the landscape. This can be done at any time of year, but a bright day will bring the best out of the colours.

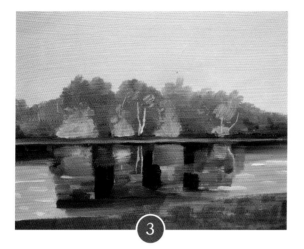

③

Block in the foreground. In my painting, I also worked on the surface of the water, adding dashes of pure titanium white. To give the effect of the white trunks of the birch trees, I used the tip of the brush handle to scratch into the painting, revealing the white primer underneath. Build up the surface of the painting, keeping in mind the pairing of complementary colours. Don't be scared of keeping the colours strong and intense.

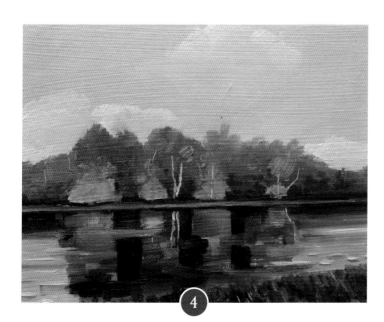

④

The final stage is to add detail – in my case, the clouds and the grass in the foreground. Again, continue to be aware of the complementary colours; I deliberately added dashes of cadmium red among the green foreground.

Subject
& Approach

John Constable: Sketching with oil paints *en plein air*

This is an exercise in painting *en plein air.* The methods and techniques that John Constable developed – using a small canvas and working on a dark ground with a limited palette and a large flat brush – will help you to make this small oil sketch. The scene I have chosen for this exercise is an urban one, dominated by two big plane trees. The large area of foliage offers the chance to experiment with Constable's broad, descriptive brushstrokes.

RECOMMENDED PALETTE
- ○ Titanium white
- ● Mars black
- ● French ultramarine
- ○ Cadmium yellow
- ● Burnt umber
- ● Burnt sienna

YOU WILL ALSO NEED
Primed canvas
Flat brushes
A solvent
Rags/paper towels

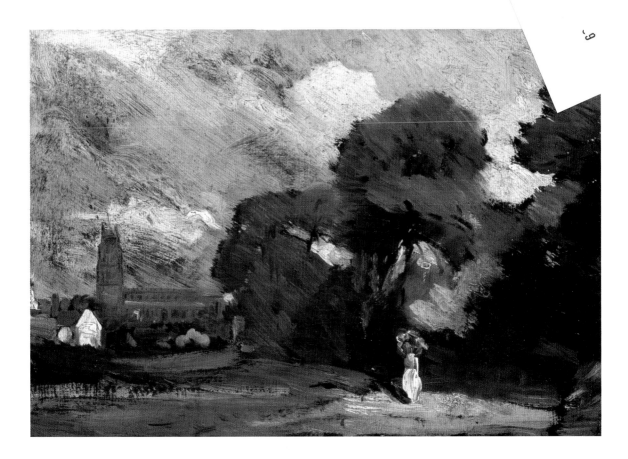

A blustery autumn day; bright sunlight breaks through the clouds and illuminates a woman as she carries her bundle through the landscape. In the distance, we can see a grand parish church standing just beyond the copse.

Constable loved the Suffolk landscape he grew up in and knew so well. He spent hours outside, painting these small oil sketches that captured the very essence of his beloved Suffolk. Over time, he developed a method that helped him to recreate the fleeting beauty of nature. He used small, portable supports, preparing them beforehand with different grounds: a pink ground for a warm summer evening or a dark brown for a stormy day. The dark ground in this painting helps create the drama of the sky and the deep shadows that give such a potent sense of depth to the scene.

Constable was keen to capture specific weather effects and worked quickly to paint scenes such as this, limiting his colour palette and working with broad, suggestive brushstrokes. There is very little detail and elements such as the church windows are only sketched in. This all helps give the painting its blustery feel.

Stoke-by-Nayland
c. 1810–11

———

John Constable
oil on canvas

Prepare your canvas board. Thin down a small amount of burnt umber and Mars black and paint it across the canvas to create a roughly uniform, dark brown surface.

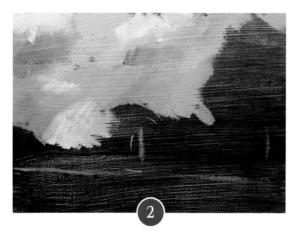

Mix a light blue from titanium white and French ultramarine and quickly block in the sky down to the trees in the middle ground and the horizon. To create the clouds, mix a cool grey from French ultramarine, burnt sienna and titanium white, and apply with swift strokes. Clean your brush, then put in the bright highlights with pure titanium white, taking care not to blend them into the grey too much.

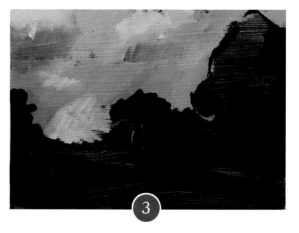

Load a clean brush with Mars black and a tiny bit of solvent to help fluidity, and block in the dark areas of the scene; don't be shy here – work boldly.

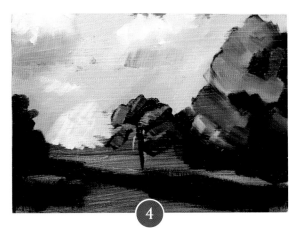

(4)

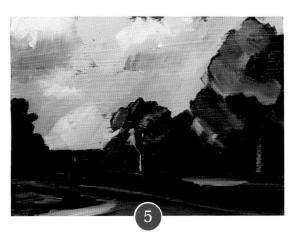

(5)

I worked on the foliage in my scene by mixing a range of greens from French ultramarine and cadmium yellow and quickly blocking them in, working right down into the black shadows. Letting the brush pick up the black paint from Step 3 will give you some subtle variations in colour and also help create some form in the foliage.

Now build up the more detailed elements of the painting. Still using the broad flat brush, I brought in the red of the building in my scene using burnt sienna. I then painted in a rough suggestion of the road with some of the same bluish grey used in the sky.

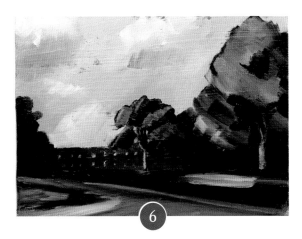

(6)

— NOTE —

When you have finished, you can turn your painting around and tape it onto the board facing inwards. This will protect it from smears and swipes; it will press some of the paint onto the board, but you can touch it up when you get back.

Finish the painting by adding a few tiny details. Use the corner of your brush and a relevant colour to dab in small elements; I sketched in the building windows and intensified the light on the tree trunks. Remember that this is a sketch: don't overwork it.

Mark Gertler: Emphasise shape and structure with a limited palette

In this exercise, we are going to elevate something mundane and humble that you might see around the house, and make it the central motif of your painting. I chose an iron because it has such a wonderful shape. Like Mark Gertler, use a limited palette and a strong outline to accentuate the shape of your subject, and add to the design by making the background geometric.

RECOMMENDED PALETTE
- Titanium white
- Mars black
- French ultramarine
- Yellow ochre
- Alizarin crimson

YOU WILL ALSO NEED
Primed canvas
HB pencil
Flat and round brushes
A solvent
Rags/paper towels

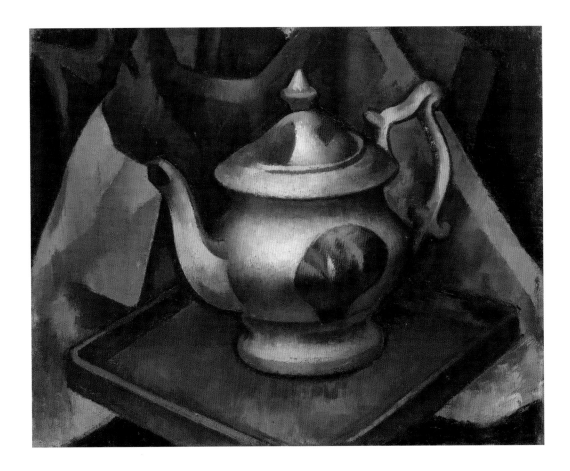

Form and structure dominate this painting. The teapot is strongly outlined and the colours are muted and quiet, emphasising its shape. Its white surface glows in the murky light, allowing it to stand out from the shadowy background. He flattens the picture plane, warping conventional perspective and playing with angles, which is particularly noticeable in the twisting spout and green tray. Gertler connects the background and the foreground, treating the angular backdrop in the same chunky geometric way.

The Tea Pot
1918
—
Mark Gertler
oil on canvas

Gertler came from a poor background, but his talent got him into the Slade School of Art, where he met artists like Christopher Nevinson and Stanley Spencer. Gertler's interest in the Post-Impressionists led him to develop his own bold, direct style. Paul Cézanne's work – especially his use of geometric shapes, his playfulness with perspective and his love of lowly subject matter – are all evident in this painting, where Gertler transforms the humble teapot into something exotic and interesting.

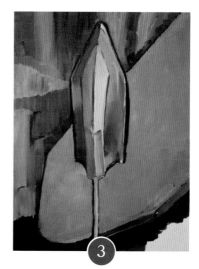

Draw the outline of your subject in pencil. It's not easy to rub pencil out of canvas, so don't worry if you make a mistake, as you are going to paint over it anyway.

Go over your pencil outline with a bold line of Mars black. Thin down a large amount of French ultramarine with a solvent, add a small amount of alizarin crimson to make a purple, then block in the background. You want to create simple geometric shapes. Create the highlights and shadows by adding titanium white or Mars black and French ultramarine.

Mix French ultramarine with a small amount of yellow ochre and mix this with a small amount of grey (black and white mixed together) to tone down the colour. Thin the mix with a small amount of solvent and apply it to your subject, leaving the highlights untouched.

NOTE

To keep the colour harmony in this painting you will be using the same few colours on all elements of your painting.

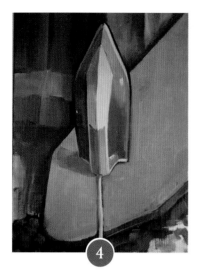

Now build up the your subject. Take the colour you mixed in Step 3 and add a small amount of Mars black. Work on building the form of your subject by intensifying the darkest areas and adding a shadow.

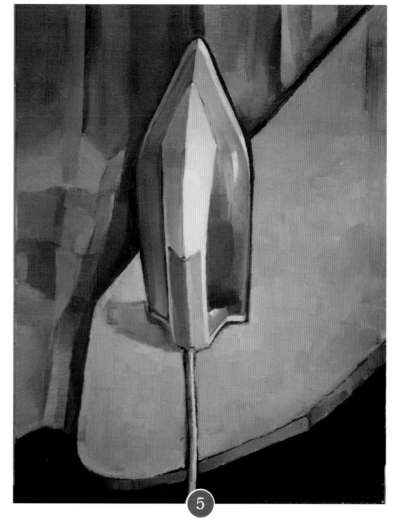

Continue to develop both the background and the foreground subject by adding some highlights and darkening the shadows. Do not thin the paint at this point, and take care not to lose the geometric shapes in the background. Use blocky, choppy brushstrokes: this will help develop the form and structure. The main focus is the iron, so the brushstrokes are more blended to give a smoother gradation of tone here than in the background; this smoothness accentuates the curve and the shape.

George Smith of Chichester: Creating the illusion of depth using aerial perspective

George Smith of Chichester created a scene that you almost feel you can step into. In this exercise, we are going to paint a landscape with a similar sense of depth and space using an aerial perspective. This will be a simple invented landscape, concentrating on the land fading into the sky, and hinting at the bluish colour that comes through in the distance. Once you have mastered the skill of suggesting depth with an aerial perspective, you can add as many foreground details as you like.

RECOMMENDED PALETTE
- ○ Titanium white
- ● French ultramarine
- ○ Cadmium yellow
- ● Yellow ochre
- ● Burnt umber
- ● Burnt sienna

YOU WILL ALSO NEED
Primed canvas
Flat brushes
A solvent
Rags/paper towels

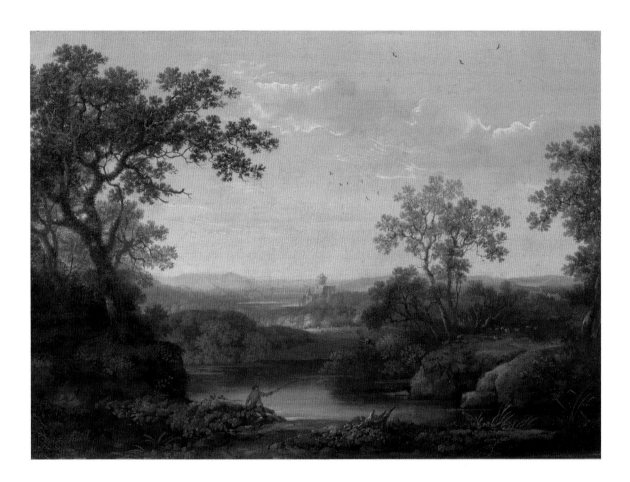

Trees frame a small lake where a man fishes and the setting sun casts a golden light across the whole scene. Everything is peaceful and balanced.

In this painting, Smith uses an aerial perspective to increase the illusion of depth. The objects in the distance become less defined, lighter in tone and bluer in colour. We can see that the trees in the middle distance fade slightly, and the hills far off on the horizon practically disappear into the sky.

This painting is typical of its time. The second half of the eighteenth century saw

Classical Landscape
c.1760–70

—

**George Smith
of Chichester
oil on canvas**

artists exploring the notions of landscape, approaching it with the different aesthetics of the picturesque, sublime or the classically ideal. Landscapes like this were painted in the studio, both from imagination and sketches from natural observation. Artists might enhance certain natural phenomena to reinforce the effects they wished to achieve. Oil paint is a brilliant medium for capturing the light effects we see in this painting. The fact that it stays wet for so long makes it easy to blend the tones and colours smoothly over several sittings.

Start with the sky by mixing equal amounts of French ultramarine and titanium white. Paint this onto the top of your canvas with broad, even brushstrokes. Clean your brush and then, under the blue, paint a band of pure titanium white, blending it into the blue. Clean your brush again and mix a little titanium white with burnt sienna to make a warm, reddish pink. Paint this under the white, blending it up through the white and into the blue.

Add a small amount of titanium white to yellow ochre and paint this under the pink, blending it up the canvas, into the rest of the sky. Clean your brush and blend a band of pure titanium white underneath all of this.

NOTE

When blending with wet oil paint on canvas, you need to use your paint quite liberally. Blending like this is only effective if there is enough paint on the canvas for the subsequent colour to mix with. Remember to turn your brush over when painting in order to use the paint on both sides of your brush.

Mix French ultramarine with a small amount of burnt umber and yellow ochre to make a dark green, and paint this across the bottom of your canvas. The dark green should look almost black, to give a dramatic contrast.

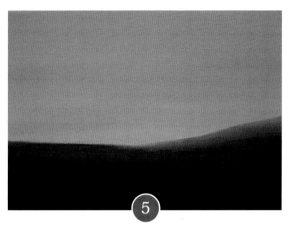

Starting with a good amount of cadmium yellow, mix in a small amount of French ultramarine to make a lively green. Paint this just above the dark green at the bottom of your canvas and blend down into it. Don't smooth everything out, as you want small inconsistencies in colour to create subtle varieties in the greens.

Now blend this up into the white band at the bottom of your sky. Raise one side to make a hill. The white at the bottom of your sky will start to fade into your landscape and lighten its tone.

Using the pale blue mix from Step 1, paint a band across the top of your greens with a small flat brush, blending it into the sky. Now blend from the green into this blue layer to create a row of hills in the middle. Use the tip of your brush to define the darker edges of your hills.

Euan Uglow: Creating form by dividing the subject into precise sections

Euan Uglow was the master of precision. He would measure and mark meticulously in order to break his subjects into small sections, which he would then build into the accurate structure and form of his subjects. In this exercise, we are going to emulate his precise approach.

RECOMMENDED PALETTE
○ Titanium white
● French ultramarine
● Yellow ochre
● Burnt sienna
● Alizarin crimson

YOU WILL ALSO NEED
Paper
Primed canvas
HB and 6B pencils
Flat brushes
A solvent
Rags/paper towels

In this painting, we see the profile of a model standing with her arms outstretched. She stares blankly ahead, her pale skin standing out starkly against the black background.

The stylised athletic pose of the model is based on a small Chinese action figure, Zagi, which explains the still, almost lifeless, feeling of the painting.

For Uglow, 'visual truth' was the holy grail of painting, rather than emotional content. This painting demonstrates Uglow's obsession for accuracy, with every aspect carefully measured.

Zagi
1981–2
———
Euan Uglow
oil on canvas

Uglow shows us the precision of his process; the marks he uses remind us that we're looking at a painting. The small, distinctly separate sections of skin tone that are pieced together to make the form of the model work in the same way, drawing the viewer's focus to the surface of the painting and giving it a certain flatness. It is this tension between the extreme accuracy and subtle abstraction that make Uglow's work so interesting.

On a piece of paper the same size as the canvas you are going to paint on, use a pencil to make a clear line drawing of your hand. Do not include any shading. If you are confident enough, you can omit this step and the next and make your drawing directly onto the canvas.

Transfer your drawing to your canvas. To do this, turn your drawing over and, on the other side of the paper, use a 6B pencil to draw dense graphite over the lines. Now turn the paper back over again, carefully place it on the canvas and trace over the drawing with a sharp pencil. This will print the graphite on the other side of the paper onto your canvas.

Give yourself a minute to look for the distinct areas of different tones and colours that make up your hand. Outline these shapes on your canvas.

NOTE

Uglow left all of his working-outs visible. You don't need to use as many marks as he does, but don't worry about covering up the outlines or the underlying lines and marks that make up your painting.

Start with the darkest tone. I've used burnt sienna, alizarin crimson and a small amount of French ultramarine to create a dark, warm brown. Add a bit of titanium white until you get the tone you want. With a round brush, paint in the dark areas with soft, fluid brushstrokes. Don't thin your paint – use it straight from the tube to get the right opacity.

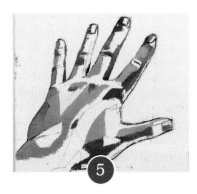

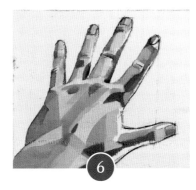

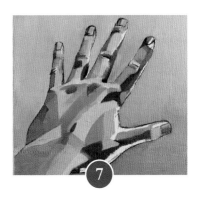

Using the same base colour from Step 4 and adding slightly more titanium white, mix two mid-tones – one lighter than the other. To create different colours rather than just lighter tones, you will need to add varying amounts of some of the colours used in the original base mix. I added burnt sienna for a pinkish colour, and yellow ochre for a more tan/yellow colour. Paint in these areas, again being careful of your outlines.

Continue to fill in your outlines, identifying and including additional shapes of tone as you go. You can always work back into the dark areas if they need to be changed slightly, but make sure you keep each area distinct.

Paint in the background. Like Uglow, you can leave this fairly flat. I chose green/grey as the main colour, mixed from French ultramarine and yellow ochre, with a bit of burnt sienna, because it will help the pinks and red of the skin tones stand out.

Finally, bring in the highlights. Look out for cool and warm areas of light. For the cooler areas, add a tiny amount of French ultramarine, and for the warmer areas, add a tiny amount of yellow ochre.

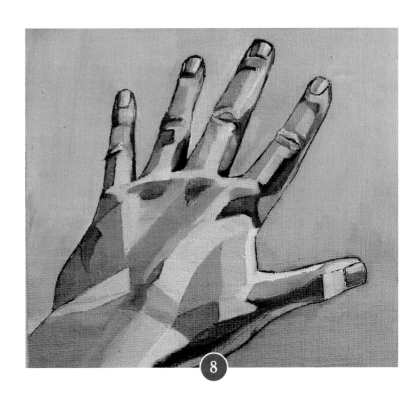

Francis Bacon:
Transforming an existing image into something new

Francis Bacon was not afraid to appropriate images in the interest of creating something new and expressive in his own painting. We are going to do something similar: manipulating an iconic film still. Bacon's style of painting was physical, almost brutal, and he pushed the medium to the limit. Oil paint is perfect for this, as it can be used in so many different ways and can take the addition of things, such as sand, to add texture.

RECOMMENDED PALETTE
- ○ Titanium white
- ● Mars black
- ● French ultramarine
- ● Yellow ochre
- ● Burnt sienna
- ● Alizarin crimson

YOU WILL ALSO NEED
Unprimed canvas
Flat and round brushes
Sand (optional)
A solvent
Rags/paper towels

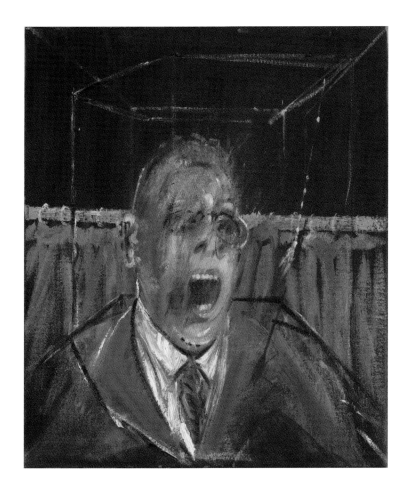

This painting has all the grotesque obscurity of a nightmare. A figure is dressed like a businessman – suit, shirt and tie – but his mouth gapes in a silent scream and his pince-nez are broken across his nose. The addition of the last detail is less strange when you realise that the reference for this painting wasn't an actual person, but a still from the 1925 film, *Battleship Potemkin*.

Bacon didn't particularly like painting from live models but preferred, instead, to appropriate existing images: paintings, like Velázquez's *Portrait of Pope Innocent X*, or images from books, like the still of a wounded, elderly nurse in Sergei Eisenstein's film, via Roger Manvell's 1944 book, *Film*. Bacon developed a fascination with this image, coming back to it several times in his work, including for this painting.

Bacon developed an idiosyncratic style to portray the landscape of the human mind beneath our external and physical trappings. Unusually, he often used raw, unprimed canvas, and allowed his paintings to evolve through accident and instinct. We are going to do the same, bringing individuality and expression to an appropriated image.

Study for a Portrait 1952
———
**Francis Bacon
oil and sand
on canvas**

Start by finding an image you want to draw inspiration from. Pick a striking image of a face. Bacon was drawn to the screaming mouth of the old nurse in *Battleship Potemkin*; I saw Marlene Dietrich's eyes as the main feature in this still from *Shanghai Express*.

Roughly draw the facial outline with thinned-down Mars black mixed with French ultramarine, then block in the background. Remember, you are not copying: I have exaggerated the eyes and the cheekbones of my still.

Now bring in the skin tone and start to work more closely on the eyes, which are the main feature. At this point, like Bacon, I added some sand directly to the surface of the painting to give it texture. For the skin tone, I used titanium white, burnt sienna, alizarin crimson and a tiny bit of yellow ochre, in different ratios, building the surface of the painting with gestural brushstrokes.

NOTE

After 1947, Bacon began working on unprimed canvas. Painting onto raw canvas means that paint acts more like a stain, as it soaks right into the material, making the early marks more permanent. The paint dries as you put it on the canvas, giving it a strange, chalky feel. It takes some getting used to, but it means that you can work layer on layer without the paint blending.

NOTE

Adding sand makes the surface of your painting noticeably rough. The process of moving the paint around becomes much more physical, so brushstrokes are more distinct and the marks naturally become gestural.

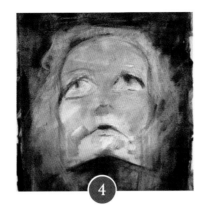

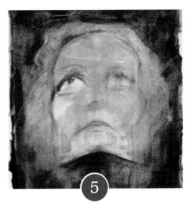

Continue to build up the surface of the painting, focusing on the key features.

Don't be afraid to wipe back the surface of the painting using a solvent and rags to create something new. Bacon often did this and it will help you to differentiate your image from your source.

Re-establish parts of your painting by using white outlines and new applications of Mars black to emphasise key features.

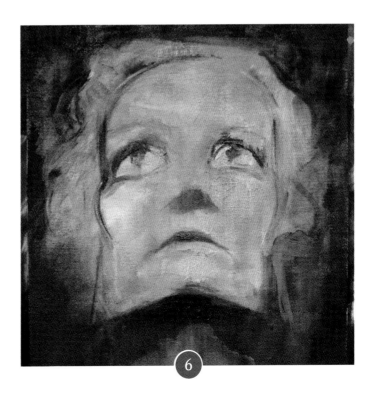

Roy Lichtenstein: Copying a mass-produced image to make an arresting painting

In this exercise, like Roy Lichtenstein, we are going to appropriate a common, mass-produced image and copy it as an oil painting. We will transfer the image precisely, using a grid, and adopt its colours and eye-catching outlines. Any attention-grabbing, commercial image with bright colours will work well for this.

RECOMMENDED PALETTE

- ○ Titanium white
- ● Mars black
- ● French ultramarine
- ○ Cadmium yellow
- ● Burnt sienna

YOU WILL ALSO NEED

Primed canvas
Flat and round brushes
HB pencil
Ruler
A solvent
Rags/paper towels

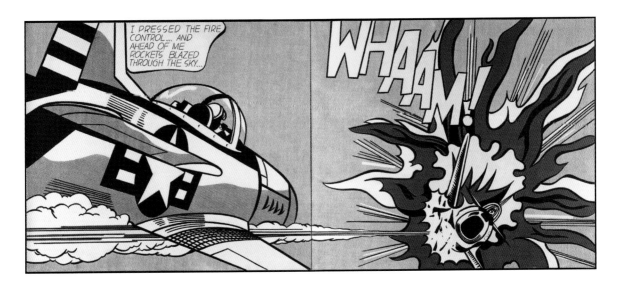

Lichtenstein's work demands attention. The scale is huge, the outlines are clear, the colours are bright and bold, and there is no ambiguity as to what we are looking at – a fighter jet blowing up an enemy plane. *Whaam!*

Lichtenstein, with his fellow Pop artists such as Andy Warhol, made paintings that were the artistic antidote to the abstract splatters and drips of the previous decade. He wanted his work to be unambiguous and immediately recognisable, and so he went for subject matter that had a ready-made aesthetic that everyone knew: the art of the comic book. This painting, for example, is based on an image from the DC comic, *All-American Men of War*.

Whaam!
1963
—
Roy Lichtenstein
acrylic and oil
on canvas

Comic books weren't Lichtenstein's only source. Any common, commercial art, like advertisements from newspapers, was in his scope. Lichtenstein transformed what was considered low art, the disposable artwork of the mass produced, to the high art of the gallery and museum. Lichtenstein's work copied the image exactly, and although he employed large stencils to emulate the uniform regimented rows of dots that made up the image in comic books, the dark outlines of the image were done freehand, bringing in the crucial combination of the industrial process and the artist's hand.

With a sharp, hard pencil, copy the image onto your canvas. It can help to number the squares of your grid for easy reference. Use the grid to plot the precise position of all the parts of your source image. Divide your squares up even further if you have to. Make small but visible marks to be sure that you are correct before committing to a line.

Divide your source image into equal-sized squares. The size of your squares depends on the size of your paper. A good square size is about 3cm (1in): if the squares are too small, it will be really fiddly; too big and it will be hard to be accurate in your drawing. If you are keeping your image the same size as the original, grid your support up in exactly the same way. If you are going 2× bigger, for example, multiply your square size by 2 – so 3-cm (1-in) squares on the source image become 6-cm (2-in) squares on your support.

Carefully paint in the areas of your source image. Make sure you mix enough of each colour so that you can apply them consistently. Don't thin your paint down (although a tiny amount of solvent will help fluidity): you want to keep your paint thick and opaque to get the solid, block-like coverage.

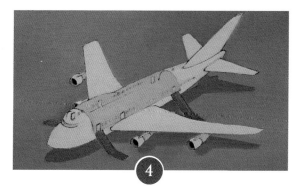

(4)

Block in the background, again being careful to keep the colour even. Keep your brushstrokes smooth and your brush loaded with a good amount of paint. In this example, I painted the lighter blue background, leaving space for the darker colour of the shadow. I mixed a darker tone for the shadow by simply adding more French ultramarine to the main background colour. When I painted the shadow, I allowed the paints to blend very slightly on the edges.

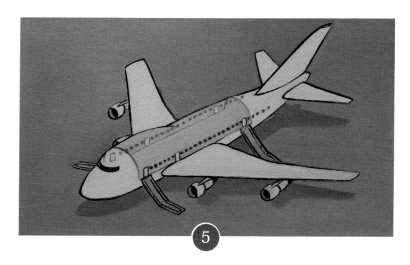

(5)

Finally, go over your outlines. Use the same colour as your source image; this will usually (but not always) be black. With this exercise, you are copying exactly from your source material, so make sure you look closely. Like Lichtenstein, paint the outlines freehand. Use a good round brush with a fine point. Add a tiny bit of solvent to your outline colour to get a more fluid consistency. Load up your brush with a good amount of paint, but get rid of any excess.

Composition
& Arrangement

Meredith Frampton: Arranging a scene to create a balanced, harmonious composition

In this exercise, using the beautifully still and precise work of Meredith Frampton as inspiration, we will paint a still life by arranging objects within their surroundings and use a muted colour palette to create balance and harmony.

RECOMMENDED PALETTE
- ○ Titanium white
- ● French ultramarine
- ○ Cadmium yellow
- ● Yellow ochre
- ● Burnt sienna

YOU WILL ALSO NEED
Paper
Primed canvas
HB pencil
Flat and round brushes
A solvent
Rags/paper towels

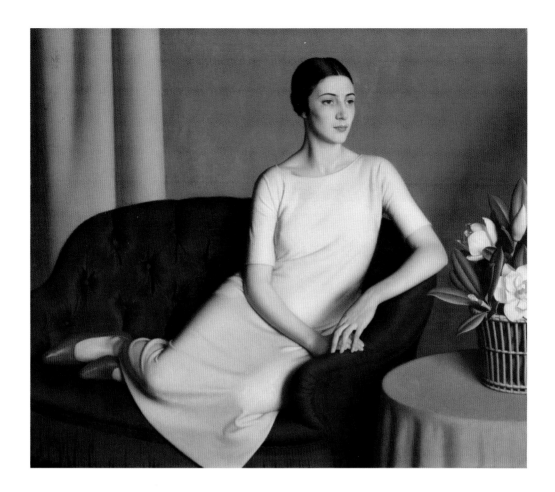

Marguerite Kelsey sits with perfect poise on a grey button-back sofa, as if frozen in time. She stares out of the frame, still and pensive. Soft natural light bathes the interior, making the soft, muted colours of the room glow. Frampton's whole composition is carefully arranged, with every element integral to the whole.

Frampton was meticulous in his preparation as well as his execution. From Marguerite's pose to the furniture and to the soft, harmonious colours, the whole scene is completely controlled by the artist. Frampton chose Marguerite Kelsey, a professional artists'

Marguerite Kelsey
1928

———

Meredith Frampton
oil on canvas

model, for her grace and her ability to hold a pose. He provided her with the shoes and dress to wear specifically for this painting. Even the light had to be perfect, with Frampton abandoning several sittings because it was too overcast.

This is a beautifully crafted composition. The shapes and structures within the frame are all balanced. The colours, the greys and the warmth of the background all have a soothing effect. All of this supports the focus of the painting: the beautiful composed face of Marguerite Kelsey.

Spend some time arranging your composition; the setting, the time of day and the elements of your painting are all important. Move things around to best support the focus of your composition. I have framed a tulip between a curtain and a column. The |curve of the stem leads up to the bloom and the small pot acts as a counterweight in the bottom right-hand corner. Draw your initial composition on paper first, using paper that is the same format as your canvas. This is the stage where things can easily be moved and reordered. Don't worry if the drawing looks a little scruffy; it's a working drawing, not a final piece.

Transfer your drawing to your canvas. You can do this whichever way you like. I did it by eye because the composition was simple enough. Other options would be to transfer using a grid (see page 88) or to trace the image (see page 80).

Apply the background colour with a flat brush to get a smooth, even surface. In my painting, I changed the colour of my background so that it was much closer to the colour used in Frampton's painting. For this, I mixed burnt sienna with titanium white to make a muted pink, then added a small amount of yellow ochre to liven up the colour.

NOTE

The lighting plays a crucial role in setting the mood of your painting. A bright afternoon will give hard, sharp shadows, whereas early morning and late afternoon will give a softer light. A thin white sheet of muslin or cotton placed between the light source and the subject will soften the light as well.

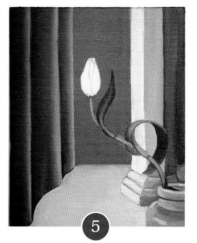

Carry on working on the background, making sure that the colours you use don't overpower the composition. The curtain on the left in my painting is dark, in order to act as a frame for the rest of the composition. I mixed burnt sienna with French ultramarine, then added titanium white to make a grey. Paint the darker areas first, making the darkest areas almost black, then blend with titanium white to give a smooth gradation.

For the pot, I wanted a warm reddish colour: I mixed burnt sienna with titanium white, adding French ultramarine for the darker areas. Where the light hits the pot on the left, I added more white, with a small amount of yellow ochre to warm it up. Use a small flat brush for the main areas of the pot and a small round brush with a fine point for the details and the highlights.

For the tulip stem, mix a dark green, starting with French ultramarine, then adding a small amount of cadmium yellow. Clean your brush and blend in pure cadmium yellow directly on the canvas, leaving the edges of the stem and leaves dark. Paint the highlights on the stem with cadmium yellow and a small amount of titanium white, blending as you go to create the smooth gradation that creates the sense of the curve.

Finally, paint the tulip flower. This is the focus of the painting, so I kept it pale with very little shadow, so that it glows bright and draws the eye.

William Chase: Rule of thirds

In this exercise we are going to use the rule of thirds to create a simple yet dynamic composition that directs the viewer's eyes around the canvas. We will use this compositional technique and colour to create a balanced and harmonious piece like William Chase's painting.

RECOMMENDED PALETTE
- Titanium white
- French ultramarine
- Cadmium yellow
- Yellow ochre
- Burnt umber
- Burnt sienna

YOU WILL ALSO NEED
Primed canvas
HB pencil
Flat and round brushes
A solvent
Rags/paper towels

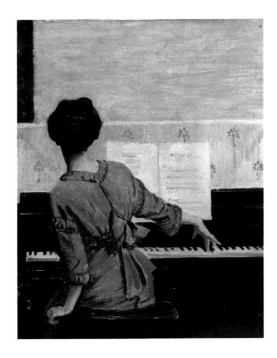

A girl in a blue dress sits at the piano. Her arm cuts across the picture as she plays a note. It's a simple scene, which is why the position of every element is so important. One crucial compositional technique Chase uses in this image is what is often referred to as the rule of thirds. This is when the picture is divided, horizontally and/or vertically into three equal parts, and the focal points of the picture are positioned on these dividing lines and their intersections.

Composition is about guiding the viewer's eye. Here, Chase moves our eye from left to right. The position of the girl on the left of the painting draws the viewer's attention first, especially as she stands out against the muted background in her vivid blue dress. The diagonal of her outstretched arm is crucial, as it leads us down to that emphatic, titular keynote. The rest of the composition beautifully supports these focal elements: the horizontals of the piano and keyboard; the pale curtains that contrast with the girl's hair, which is as dark as the piano she is playing, and the empty space that Chase has left in the top right of the image. It is no coincidence that the only colourful element in the composition is the girl's dress. Every aspect, position and colour has a role to play in the composition.

Chase uses the rule of thirds because at the heart of this compositional technique is balance and poise. Placing your subject in a central position gives you symmetry, but off-setting your subject gives your painting balance as well as tension. It is important to remember that you never have to stick rigidly to these compositional techniques, but they're always good to have in mind.

The Keynote
1915
—
William Chase
oil on canvas

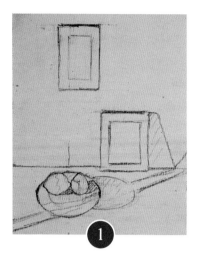

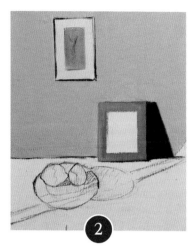

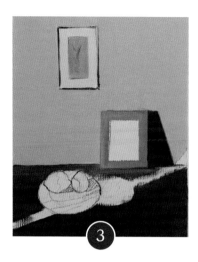

Plan your composition. You don't need to draw a grid on the canvas (although you can if you like) – it's okay to follow imaginary guidelines more loosely. Spend some time thinking about where the key elements of your painting are going to go. I've put the top of the wooden sideboard on the lower horizontal third, and the plate of fruit and the picture on the wall on the left-hand vertical third. I've also drawn in the shadow, which gives a definite diagonal across the composition. Feel free to adapt things slightly from what you really see in order to help your composition. When you are satisfied with the balance of the elements, draw their outlines in pencil.

Deciding which colours to use is part of planning your composition, as they will be integral to achieving a sense of balance. I chose to make the top half of the painting a neutral grey mixed from French ultramarine, titanium white and burnt sienna to help the colours of the fruit and the blue of the painting on the sideboard stand out. The grey also helps the space in the top right corner recede slightly, so as not to compete with the focal elements.

The warm wood colour is relatively flat and unobtrusive. Mix it from burnt sienna, a little burnt umber and a tiny bit of yellow ochre, and apply with a small flat brush, cutting in carefully around the bowl of fruit and the shadow. In my painting, I started with the background and painted the surrounding elements separately, leaving the focus of the composition until last. This way, I maintained a clear idea of how the focal parts of my composition – in this case, the fruit – would work with them.

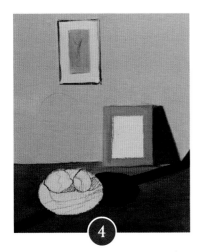

The dark of the shadow stands out against the brown of the wood. It creates a definite compositional component; it breaks up the horizontals and moves the eye across the image. For a really dark shadow, mix French ultramarine with burnt umber. You can alter the tone of this shadow, depending on what works in the painting, even if it's not a realistic tone.

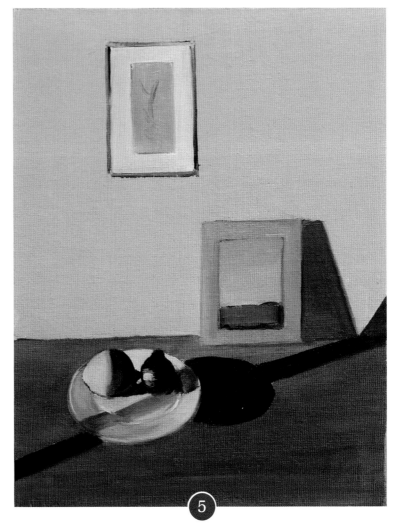

Finally, bring in the focal point. For the bowl, I used the grey mix from Step 2, adding more French ultramarine for the shadows and cadmium yellow for the lemon's reflection. The colours of the fruit also provide a resting place for the eye, especially the bright yellow of the lemon.

Lisa Milroy: Painting a repeated series to create a pattern

In this exercise we are going to use Lisa Milroy's work for inspiration by depicting an object that we often come across or use regularly in our daily life. You can paint your object either from imagination or observation, repeating it across the canvas in an ordered composition.

RECOMMENDED PALETTE
- ○ Titanium white
- ● French ultramarine
- ○ Cadmium yellow
- ● Burnt umber

YOU WILL ALSO NEED
Paper
Primed canvas
HB pencil
Ruler
Flat and round brushes
A solvent
Rags/paper towels

Twelve pairs of shoes are laid out in front of us, black and shiny, their interiors warm tones of tangerine. The shoes lie in three rows on an off-white ground. The composition might seem almost clinical if it weren't for the lively way Milroy paints the shoes, using a range of bold, loose brushstrokes. Against the off-white ground, the shoes become a series of simple forms, that suggest a range of associations, from mussels and seashells to dancing to a code or cipher.

Shoes
1985
—
Lisa Milroy
oil on canvas

Milroy treats the whole canvas in a similar manner – the pairs of shoes are the same, painted in the same way, occupying the same size of space on the canvas. The difference lies in how the shoes have been put together as a pair, in their placement or arrangement, and this positioning creates a compelling rhythmic pattern. Milroy's painting makes the ordinary seem unfamiliar, transforming the everyday into something mysterious.

Work out your composition on paper first. This way it's easy to change things – but make sure the paper is the same ratio as your canvas, even if it's not the same size. With a ruler, divide the page up into regular sections and draw your object in those spaces, experimenting with angles.

When you're happy with your composition, transfer it in pencil to your canvas.

NOTE

This first step is possibly the most important. Try out different patterns and arrangements. Be as aware of the space between the objects as you are of the objects themselves.

With oil paint, it's best to work from dark to light. Begin with thin applications of paint and gradually build up the layers. Start with dark green. Mix French ultramarine with a tiny amount of cadmium yellow. Paint the shape of each bottle with your green, leaving spaces for the labels – you can apply the paint as a flat block of colour, or gently modulate the paint to give the object form.

With a flat brush, paint the white background. Apply the paint thinly, but aim to get a good solid coverage of white.

Mix a tiny amount of French ultramarine to cadmium yellow to get a yellowish green. With a round brush, use this to build up and enhance the lighter areas of the objects. Keep a contrast between the darker and lighter areas to create a sense of volume. Use pure titanium white to add some highlights, leaving some brushstrokes unblended to give more intense lighter areas.

Keep your eye on the exciting interplay between the brightest and darkest areas of your object, and enjoy bringing out the contrast.

Mix French ultramarine and burnt umber to make a black tone. With a good-quality round brush, paint in the shadows beneath the bottles directly onto the white background – which will still be wet – in one smooth stroke. This will give a subtle fade to the shadow. Use this mix and titanium white to paint the labels.

Robert Delaunay: Cropping to alter the visual effect

In this exercise, we are going to use Robert Delaunay's technique of cropping a painting to change the feel of the final image. Delaunay painted an entire cityscape, but any painting that shows a whole object realistically will work; the key thing to learn is how zooming in can change the composition of a painting.

RECOMMENDED PALETTE
- ○ Titanium white
- ● French ultramarine
- ○ Cadmium yellow
- ● Yellow ochre
- ● Burnt sienna

YOU WILL ALSO NEED
Paper
PVA glue
HB pencil
Flat and round brushes
A solvent
Rags/paper towels
Card
Stanley knife or scalpel

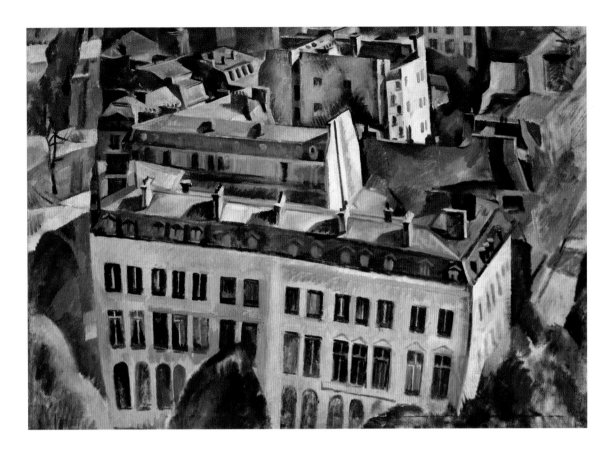

This is Paris as seen from the Arc de Triomphe, looking out towards the Eiffel Tower. The distinctive grey rooftops and white-fronted apartments zigzag up to the top of the canvas, towards a horizon that we can't quite see. This view comes from a picture postcard, a photograph of the city, with the Eiffel Tower in the distance; but there's no Eiffel Tower in Delaunay's painting.

This is an interesting composition. Delaunay positions the viewer right in the city, cutting off the horizon. It's a view that he painted repeatedly. The jumble of buildings and the angles of the rooftops, chimneys and windows gave him the perfect vehicle to push the pictorial

**Study for 'The City'
1909–10**

———

**Robert Delaunay
oil on canvas**

boundaries towards abstraction. The lack of any sky or horizon diminishes the sense of space and depth and emphasises the abstract lines and angles of the buildings.

How much we show, or don't show, in our painting has a significant effect on how the viewer understands it. Delaunay's original painting showed the whole scene right up to the horizon and included the Eiffel tower. When it was finished, he literally cut off the top of the painting, completely changing his composition. It is more common to make compositional decisions at the beginning of a painting, but this technique shows that it is never too late to change things.

Draw the outline of your subject in pencil on a large piece of paper that's been sealed with a diluted layer of PVA glue. Using paper will make it easier to cut down the final painting, but any support that you can cut will work. I have chosen a rose for this exercise, because of the possibilities the curves and angles of the petals offer, but you could try it with anything. Work large, making sure you fill the page.

For the petals, mix French ultramarine and burnt sienna and, with a flat brush, work over the outlines and block in the darker areas. Simply and loosely paint in the stem and leaves. For the dark greens, add cadmium yellow to French ultramarine. For paler greens, such as the underside of the leaves, add a tiny bit of titanium white to the mixture.

Block in the background, keeping it simple. In my painting, I used a pale blue mixed from French ultramarine and titanium white: it's a different approach from Delaunay's cityscape, but it's effective for this painting.

Bring the lighter areas into your painting. Mix a tiny amount of yellow ochre and burnt sienna with titanium white to get a warm glow in the lighter areas, and then pure titanium white for the lightest parts. Blend these wet-on-wet with the cool and warm areas of shadow; this will help give the feeling of volume. A medium-sized round brush is good for this.

Cut an aperture out of a piece of card to make a frame. The size will depend on the size of your painting. Move the frame around your painting until you land on a composition you are happy with, but make sure that you are cutting out any kind of background reference.

With a pencil, draw the frame of your new composition. Using a sharp scalpel or Stanley knife, cut out your new composition from your original painting.

Edward Burne-Jones: Creating a composition with rhythm

In this exercise, we are going to emulate Edward Burne-Jones's use of rhythm by taking an everyday subject, such as clothing on a washing line, and simplifying and stylising it to create a decorative painting with a sense of movement. Whatever subject you choose, emphasise the angles and shapes so that they guide the viewer's eye in the direction you want – in this case, from left to right.

RECOMMENDED PALETTE
- Titanium white
- French ultramarine
- Cadmium yellow
- Yellow ochre
- Burnt sienna
- Cadmium red

YOU WILL ALSO NEED
Primed canvas
HB pencil
Flat and round brushes
A solvent
Rags/paper towels

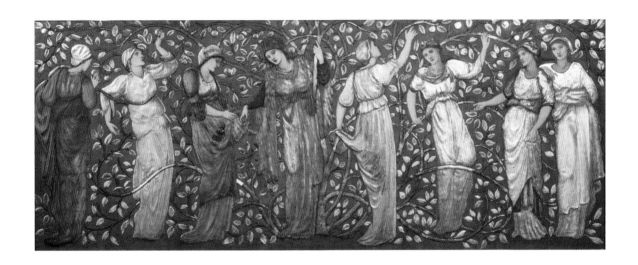

The eight ladies of the title shimmer gracefully across the picture. They pick the apples from the golden-leafed tree, as its branches twist and wind around them. This scene is possibly based on the Garden of Hesperides, the orchard of Hera where a single apple tree produced golden apples, a theme that Burne-Jones returned to a number of times.

Burne-Jones was influenced by the Pre-Raphaelite Brotherhood in the mid-nineteenth century, but later developed his own approach, stylising nature rather than copying it exactly.

Burne-Jones's whole composition has a beautiful movement and rhythm to it.

**Frieze of
Eight Women
Gathering Apples
1876**

———

**Edward Burne-Jones
oil on wood**

His use of gold is reminiscent of the work of pre-Renaissance artists, and it helps give the image its flat and decorative feel.

This flatness accentuates the flowing lines of the tree's branches, the women's poses and the soft, hanging drapery of their dresses. Your eye isn't drawn into the distance with any illusion of depth but rather moves across the surface of the image. Although detailed, with the figures and their dresses beautifully described, the painting is not entirely naturalistic, and the image has an overriding simplicity due to its structure and composition.

Start by working out your composition. I laid some shirts down on the floor, trying to create a sense of flow in the way I placed them. Mix your background colour. To echo Burne-Jones's decorative use of gold, I decided to use a warm mustard colour, which I mixed from yellow ochre and a small amount of burnt sienna. Thin your chosen colour down with a solvent and paint it onto your canvas with smooth, horizontal brushstrokes. When it's dry, draw out your composition in pencil.

Mix French ultramarine and burnt sienna to make a dark colour. Thin it down with a small amount of solvent, then, with a thin round brush, go over your pencil outline.

I chose to paint these shirts in the three primary colours, as I wanted to keep them soft and not too overpowering, like the women's dresses in Burne-Jones's painting.

For the red of the first shirt, I mixed cadmium red with a tiny bit of French ultramarine and titanium white, to soften the intensity of the colour. For the darker areas, I added a small amount of the mix used for Step 2, and for the lighter areas, a small amount of titanium white. There are no big tonal distinctions, however, so keep everything smooth and subtle.

For the blue shirt, I added a small amount of French ultramarine to titanium white, and then added a tiny bit of burnt sienna; this makes a soft, light blue. As in Step 3, darken your colour with the burnt sienna and French ultramarine mix and lighten it with titanium white.

For the yellow shirt, I started with titanium white and added a small amount of cadmium yellow, yellow ochre and a tiny amount of burnt sienna to soften the intensity. For the darker shades, I used the burnt sienna and French ultramarine mix. Be careful, because too much blue will make your yellow turn green – so you might need to add slightly more burnt sienna.

Go over the background, keeping it flat and uniform. I went for a warm coppery colour by mixing burnt sienna, yellow ochre and titanium white. Put in the final touches, always being aware of the rhythm of your composition. I simply added the swooping washing line for the shirts to be pegged to. At this point, stand back from your painting and look at it with fresh eyes. Is there a part of your painting that distracts you from the overall composition? It might be something as simple as an area of tone that is slightly darker than the rest. Make any necessary adjustments.

NOTE

Once you have painted your subjects, you can add a patterned background to add to the rhythm of the piece like Burne-Jones has.

Pattern, Surface
& Abstraction

Henry Bishop: Creating an arrangement of colour and texture

In Henry Bishop's painting, the colours and textures of the scene are the focus of the painting. In this exercise, we are going do something similar. Looking at buildings or structures square-on diminishes the sense of depth and highlights the more abstract elements of a composition.

RECOMMENDED PALETTE
○ Titanium white
● French ultramarine
● Yellow ochre
● Burnt umber
● Burnt sienna

YOU WILL ALSO NEED
Primed canvas
HB pencil
Flat, angle and round brushes
A solvent
Rags/paper towels

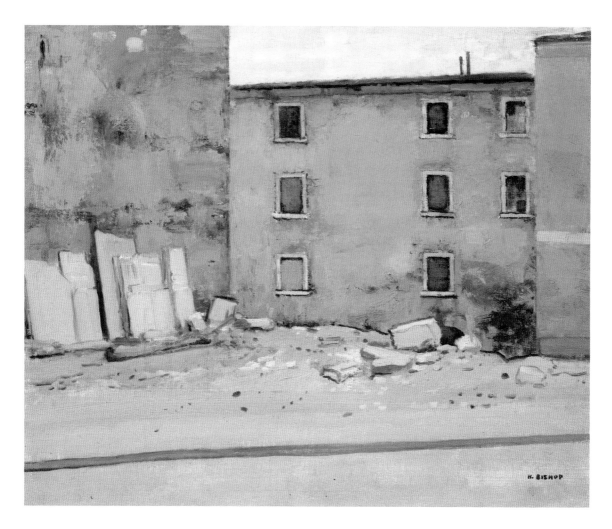

Marble slabs lie stacked and strewn in a small, dusty yard. The walls of three colourful buildings are mottled and crumbling yet still seem to glow in the soft light of an overcast day.

This small, unassuming street scene captures the colours and textures of the Tuscan marble-quarrying town, Carrara. Bishop picks an unusual view for this composition. The houses and the slabs give us an indication of where we are, but there is no sense of perspective to give the painting depth.

This has the effect of flattening the image into just an arrangement of colours and shapes on the surface of the canvas.

The colours and textures of this scene are created by the way that Bishop puts the paint on the canvas. The walls are not simple blocks of colour: he emulates the roughness and the feeling of those surfaces peeling and flaking by building up the painting with layers of paint, and allowing the bottom layer to show through.

A Street in Carrara
exhibited 1926
———
Henry Bishop
oil on canvas

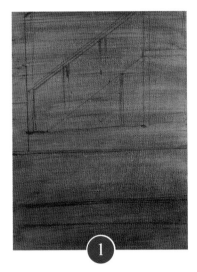

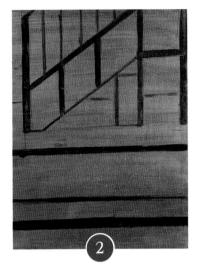

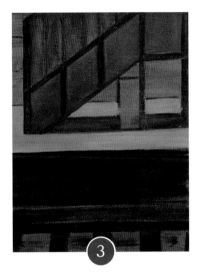

Sketch out your composition on paper first. Choose something with strong, geometric shapes to work with. I chose a staircase, a section of a train station platform and train tracks for my subject. This gave an interesting arrangement of shapes, and the texture of the old paint on the panels and the concrete of the platform was very appealing.

Prepare your canvas with thinned-down burnt umber. This background colour will give an overall warmth to the painting.

Paint the outlines of your composition in a dark mix of burnt umber and French ultramarine. Make the lines thick as you will paint over them.

Block in the darker undercolours. For the blue panels of the staircase, I mixed French ultramarine with a small amount of burnt umber; for the tall windows above the panels, I mixed burnt sienna and burnt umber; and for the darkest area of the platform, I mixed French ultramarine and burnt umber. I used an angled brush for this, because it was perfect for getting into the tight angles. The grey of the platform is French ultramarine and burnt sienna (a little more burnt sienna to make it a bit warmer), mixed with titanium white.

> **NOTE**
>
> This background will be painted over, leaving some areas showing through, so consider your background colour carefully before you begin.

Build up the layers without thinning your paint; you are now painting lighter tones of the same colours over the top. For the blue panels I mixed French ultramarine and titanium white, then apply the colour with an angled or flat brush, dragging it across the canvas and lessening the pressure as you go, so that the paint doesn't completely cover the canvas but just catches the top of the weave.

Repeat this technique on the warmer areas of the windows and the darker platform area with a lighter tone of titanium white, burnt sienna and yellow ochre. Work in layers to lighten the main highlights. For the tracks, simply paint the highlights with a lighter mix of titanium white, French ultramarine and burnt sienna, and use French ultramarine mixed with burnt umber for the darkest shadows.

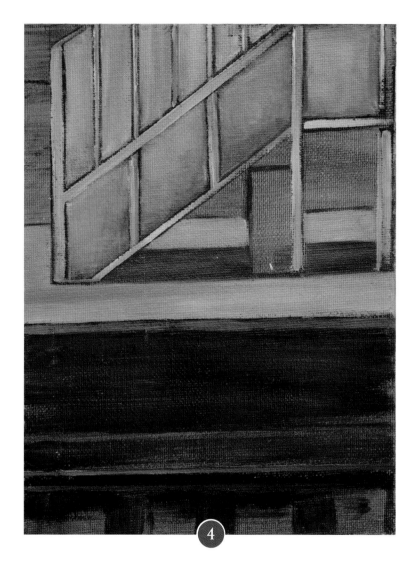

4

NOTE

Do not over-describe any elements in this type of composition: the elements within the painting should be recognisable but simplified.

Raoul Dufy: Using repeated marks and strong colour to create a decorative scene

In this exercise, following the example of Raoul Dufy, we will use simplified, descriptive patterns that sit on top of bold blocks of colour to create a bright, decorative piece. The key is to not overwork things. You want to be informed by what you are painting without copying the scene exactly.

RECOMMENDED PALETTE

- ○ Titanium white
- ● French ultramarine
- Cadmium yellow
- Naples yellow
- Yellow ochre
- ● Burnt sienna
- ● Cadmium red

YOU WILL ALSO NEED

Unprimed textured paper
Flat and round brushes
A solvent
Rags/paper towels

This is an idyllic scene, and even in 1929 the painting was seen as nostalgic. We see a bright hillside as a backdrop to a full and healthy harvest that is being gathered in by a farmer and three colourful Shire horses. In the foreground, two swallows swoop in delight. This is the sort of joyous subject that Dufy loved to paint and for which his bright, exuberant painting style was perfect.

Dufy wasn't just a painter, he was also a designer and an illustrator. With his eye for expressive marks and patterns, almost calligraphic in their style, he created recognisable but stylised scenes. In 1905, Dufy saw the bright Fauvist work of Matisse and fell in love with the intense, powerful colours that were used. This, combined with his distinctive marks, make Dufy's style incredibly distinctive.

Dufy was not interested in the effects of sunlight in nature, he wanted the boldness of his colours to be the light within the painting instead. Although this particular work could be mistaken for a gouache painting, the intensity and boldness of the colours are best achieved with oil paint.

The Wheatfield
1929

———

Raoul Dufy
oil on canvas

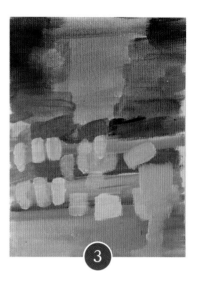

Block in the background and the foreground. Thin the paint with a solvent so that the paint goes on like a wash and dries quickly. Use yellow ochre for the background and mix it directly on the paper with burnt sienna and French ultramarine around the edges. For the foreground, mix a very light blue from titanium white and French ultramarine. Apply the paint loosely with a flat brush.

Still working loosely, block in the middle ground with what will be the focus. Like Dufy, build up your painting with separate bands of colour. For the green, add a small amount of French ultramarine to cadmium yellow. For the blue, use the mix from before but with a bit more French ultramarine mixed in. Keep your colours simple and bright.

Begin to bring in detail, but don't worry about being too precise. You will now work on top of the colours you've already laid down. For the pots, use pure titanium white. This will pick up the blues and the greens that you are painting over. If the colours start to blend, don't worry: clean your brush and work on top until you get the desired opacity.

NOTE

In order for the bottom layer to dry quickly, so that you can paint the outlines and patterns over the top of the blocks of paint, I used unprimed paper. This will draw the oil out of the paint, speeding up the drying process.

4

5

Block in areas of bright colour to create a base for the flowers using cadmium yellow, Naples yellow and cadmium red mixed with titanium white. These areas of colour do not have to describe their shape, as you will draw that on top. Keep the colours bright and simple, painting a second or third layer if the first is not vibrant enough.

Using a small round brush with a good point, paint in the outlines of the pots. Use French ultramarine straight from the tube for this and keep your marks loose and spontaneous.

6

Work in the patterns and marks that will describe what you are painting. Simplify the shapes and patterns, and use your imagination to create the scene.

Spencer Gore: Creating a painting using stylised shapes and geometric pattern

In this exercise, we will explore Spencer Gore's style of using simple geometric shapes to represent nature. The painting is representational of a realistic scene but also contains strong abstract elements.

RECOMMENDED PALETTE

○ Titanium white
● French ultramarine
○ Cadmium yellow
○ Naples yellow
● Yellow ochre
● Burnt sienna
● Cadmium red

YOU WILL ALSO NEED

Primed canvas
HB pencil
Flat and round brushes
A solvent
Rags/paper towels

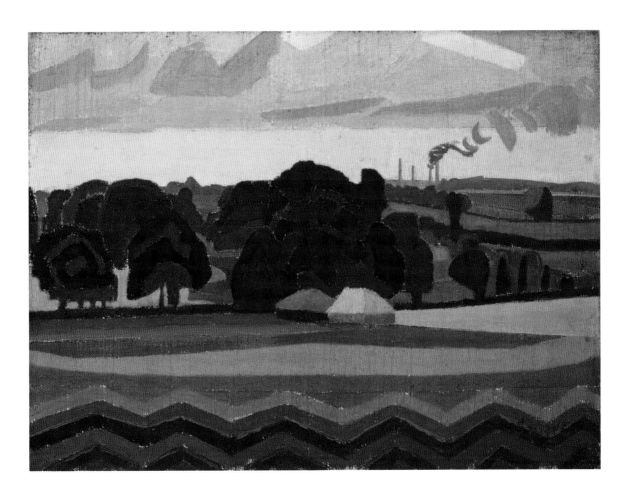

In this small (30.5 × 40.6cm/12 × 16in) painting by Gore, we see a field bordered by trees with the factories and smoke of the town of Letchworth in the distance. Overhead, a band of deep yellow sky glows beneath the clouds. Although we can still clearly see that this is a landscape, Gore's use of pattern and his stylised simplification of certain features takes it away from the traditional approach of a landscape painting.

There is a subtle tension between the urban and the rural, as well as a stylistic tension between the realistic and the abstract. Gore constructs this painting with **simplified** layers and blocks of semi-naturalistic colour, with the bean field rendered as a simple zigzag pattern that borders the foreground.

Maybe more so than some other British artists of the period, Gore was aware of the works of artists on the continent such as Paul Gauguin and Paul Cézanne. These influences fired Gore's interest in pattern and the emotional power of colour.

The Beanfield,
Letchworth
1912
—
Spencer Gore
oil on canvas

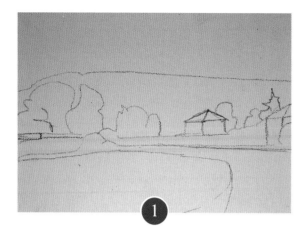

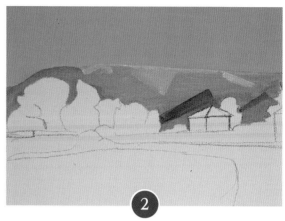

I worked from a photograph, but you could also work from observation or your imagination. On your primed canvas, draw the outline in pencil, simplifying the shapes and leaving out extraneous detail.

Mix a medium blue from French ultramarine and titanium white and paint the sky. Mix burnt sienna with cadmium red and titanium white to make a warm pink colour for the band of pink cloud. Use Naples yellow and titanium white for the highlights. Look for two or three shapes in the cloud cover and simplify them; they can be angular and boxy, if you want.

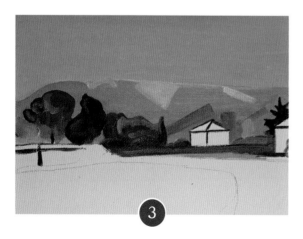

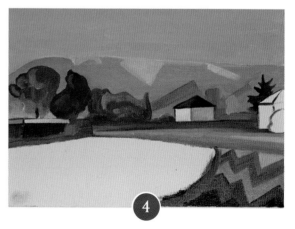

Paint the trees in the middle ground. Mix a simple green: start with cadmium yellow and yellow ochre, and add French ultramarine to this. Mix a large amount, because you will use this colour again. Use your outlines to guide you, but don't be afraid to adapt and change as you go. For the shadows, mix a blue-grey colour by combining French ultramarine, a small amount of burnt sienna and titanium white.

I replaced the pavement in my scene with Gore's geometric zigzag (you can substitute any geometric pattern that works for your painting). To keep a consistent colour palette, I used the pinks and blues that I had already mixed.

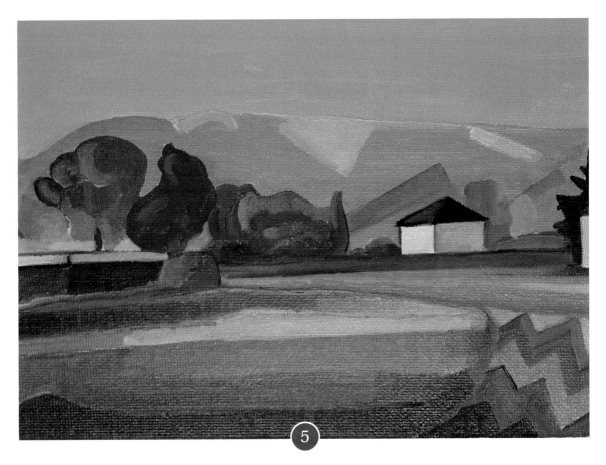

For the grass area in the foreground, emulate Gore with rectangles of green. Use the green that you mixed before as a base that you adapt. If you want your painting to be more abstract, you can make these layers of colour less naturalistic, using bright reds or blues, for example.

--- NOTE ---

There is no ground for this work, so do not thin your paint down too much, although a tiny amount of solvent will help the flow of your paint.

Charles Ginner:
Breaking a scene down into distinct shapes and patterns of colour

In his painting, Charles Ginner creates an intricate jigsaw of colour, highlighting nature's patterns. In this exercise, we are going to concentrate on the shapes and lines within the scene that we are painting, using them to create pattern and depth.

RECOMMENDED PALETTE
- ○ Titanium white
- ● French ultramarine
- ○ Cadmium yellow
- ○ Naples yellow
- ● Yellow ochre
- ● Burnt sienna
- ● Cadmium red

YOU WILL ALSO NEED
Primed canvas
HB pencil
Flat and round brushes
A solvent
Rags/paper towels

This painting of a bright London park, looking towards Big Ben and the Houses of Parliament, looks as if could be a stained-glass window, straight from a fairytale. Ginner layers the central flower bed up with the shapes of foliage to create a mountain of colour, with the spires of London peeking out from behind. The clouds and the sky take on a soft appearance, enhancing the fairytale feel of the painting.

Ginner painted scenes as he saw them around him but with the influence of the Post-Impressionists, including Van Gogh, whose work he saw in 1910 at Roger Fry's exhibition, *Manet and the Post-Impressionists*. Following this, Ginner shifted the focus of his paintings to colour and pattern, while still depicting real-life scenes.

This work has a wonderful tension between the illusion of depth, achieved through lightening the tones in the distance, and the flattening of the picture's surface, by isolating separate areas into flat blocks of colour and outlining them with dark paint. Ginner uses the richness and thick consistency of oil paint to build up sculptural areas of paint.

Victoria
Embankment Gardens
1912
—
Charles Ginner
oil on canvas

Draw the outline of your scene in pencil. Concentrate on finding the shapes and don't be afraid to exaggerate and accentuate.

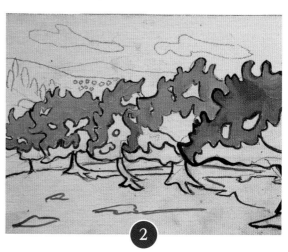

Mix French ultramarine with a tiny bit of solvent to get a fluid consistency. With a small round brush, paint over your outline, ignoring the background. Mix a light green from cadmium yellow, Naples yellow and French ultramarine, and block in the top area of the trees with a flat brush. Don't blend the colours together.

Mix French ultramarine with a small amount of burnt sienna to make a dark, bluish purple, and block in the darkest areas. Add more French ultramarine to your original green and block in the other shapes of foliage. Remember that this is not a representational painting: it's about creating interactive patterns as well as painting trees.

NOTE

Choose a scene or landscape that has plenty of organic shapes to paint. I selected a photograph of an olive grove with hills in the distance.

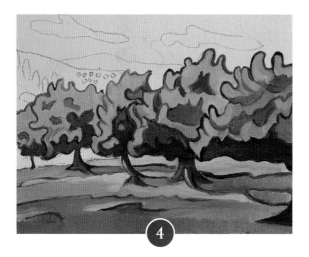

4

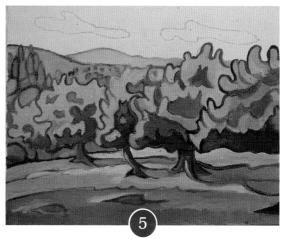

5

Use bright, warm colours – cadmium yellow, cadmium red and yellow ochre – for the foreground, and strong blues for the shadows. Paint the tree trunks in a mix of burnt sienna and Naples yellow, using Naples yellow on its own for the lighter areas. Again, don't blend these into each other.

Go over the outline of the middle-distance elements in cadmium red, adding a small amount of titanium white to soften it. For the background, use a similar palette as the middle ground, but add titanium white and a small amount of French ultramarine to fade the colours slightly.

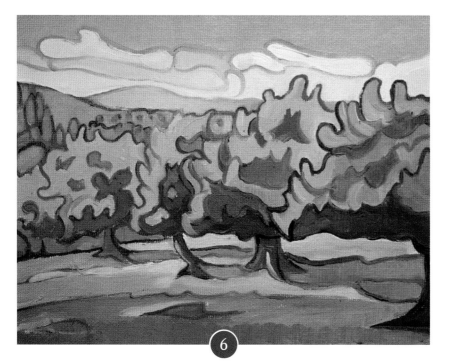

6

For the sky, mix a small amount of French ultramarine with titanium white, and paint the clouds in different tones of blue. Like Ginner, paint outlines around the clouds, to emphasise their shapes.

Piet Mondrian: Making preparatory paintings to plan an abstract piece

This painting is an early example of what eventually became Piet Mondrian's recognisable style of geometric abstract painting. In this exercise, we are going to look at the way Mondrian carefully planned and finessed his work to create his visually striking images.

RECOMMENDED PALETTE
- ○ Titanium white
- ● Mars black
- ● French ultramarine
- ○ Cadmium yellow
- ● Cadmium red

YOU WILL ALSO NEED
Paper
HB pencil
Primed canvas
Flat brushes
Stanley knife or scalpel
A solvent
Rags/paper towels

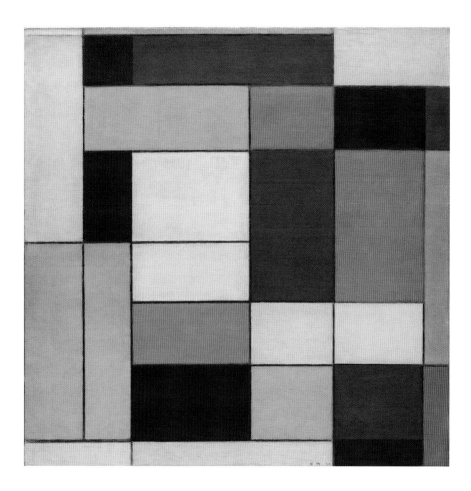

Different-sized rectangles of blue, orange and yellow, punctuated with black and grey, stack and slot together, each rectangle neatly enclosed by black lines. On the surface, this is a simple painting, but there is a subtle complexity here. Nothing is accidental – the position and colour of each rectangle is vital to the harmony of the whole piece. Mondrian would take months, or even years, shifting the lines and changing the colours until he was completely happy with a composition.

No. VI /
Composition No.II
1920
—
Piet Mondrian
oil on canvas

Mondrian's method of geometric abstraction evolved throughout his career. His early work was representational of his subject, but over the years, he moved towards simplifying the world he saw around him, until his paintings were finally stripped back to the fundamental building blocks of horizontal and vertical lines, and pure primary colours.

Mondrian's abstract painting is all about control. Replicating his style requires careful preparation and meticulous attention to detail. He preferred to use rectangles, but you can use other shapes.

A geometric abstract painting like this is all about preparation, so before you start painting, work out what you are going to do. On a piece of paper the same size as your canvas, draw out your design. I decided to deviate from Mondrian's rectangles, using parallelograms instead. Keep them all the same size at this planning stage, so that you can move them around easily.

Mix your paints – keep the mixes simple, as you will need to be able to replicate the colours exactly. You can even use paint straight from the tube if you like. Using a Stanley knife and a ruler, cut out the shapes. Paint the shapes in your chosen colours – Mondrian preferred to use primary colours, but you can mix things up. Arrange the shapes in different orders to find out which works best as an image.

This planning stage is critical, so take your time and experiment with different combinations until you have a design that has both balance and a sense of energy.

NOTE

Keep your palette simple by using no more than two different tones of the same colour. I used two tones of green and red, and one simple light blue. Don't forget white, as it can create a feeling of space.

3

Draw your design lightly on the canvas (using too much graphite will corrupt the colour of your paint).

4

Paint your first shape on the canvas. To paint a straight line freehand, use a flat brush sideways. Load the brush with a good amount of paint, wiping off any excess, and make sure that the top edge is sharp. Then, in a smooth, fluid motion, run the brush along your straight outline. Make sure you thoroughly clean your brush between applications so that you don't contaminate your colour mixes.

NOTE

Another way of achieving a straight line is to use a straight, sharp blade as a guard, rather than a ruler. I wouldn't recommend using masking tape, as there's a risk the tape might stick to your painting.

5

Continue painting the shapes. Move around your canvas to get yourself in a comfortable position or, if your canvas is small enough, move this around instead. Don't contort yourself to reach a part of your painting, as that will only lead to mistakes. Leave to dry, and then add lines between your shapes in Mars black, using a small flat brush.

Gerhard Richter: Applying paint in different ways to create an abstract piece

In this exercise, we're going to take inspiration from Gerhard Richter's rich and layered painting to create an abstract piece. We will use a limited palette and apply the paint in a variety of ways, similar to those utilised by Richter.

RECOMMENDED PALETTE

○ Titanium white
● Mars black
● French ultramarine
○ Cadmium yellow
● Cadmium red

YOU WILL ALSO NEED

Primed canvas
Flat brushes
Palette knife or
 homemade alternative
A solvent
Rags/paper towels

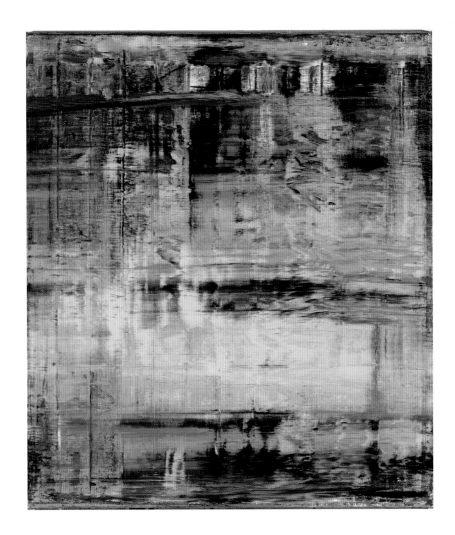

This is an abstract painting; there is no recognisable subject. It has the feeling of something just beyond us, an image tantalisingly out of sight. It is all about the build-up of layers, which are sometimes scraped back or peeled away to reveal what is underneath.

Dramatic abstract paintings are only one of Richter's variety of styles. The raw physicality of these works comes from Richter's unusual ways of working the paint with the variety of tools he uses – things like building tools, such as brick-laying trowels, and a large scraper that he made himself from a piece of wood and a strip of Perspex. Richter smears and brushes the paint directly onto the canvas, then drags and stretches it across the surface of the painting. The paint is then scraped back to reveal the lower layers, before Richter blurs it all again with the scraper. There is a freedom of process with Richter's abstracts.

Abstract Painting (809-03) 1994

—

Gerhard Richter oil on canvas

Start with dark colours for the lower layers. This will create contrast as you build the layers up. Thin down your darkest colour to allow it to dry more quickly, and use swift, horizontal strokes to loosely cover the canvas. Wipe your brush and then do the same with a second colour. I covered a quarter of the canvas with Mars black and three-quarters with French ultramarine, letting them blend and merge together. This should not be precise: be loose and fluid with your brushstrokes.

Like Richter, I made my own scraper by cutting the card at the back of an old sketchbook to the exact width of my canvas board, but you could use a palette knife. Squeeze your next paint directly onto the edge of the scraper. I chose pure cadmium red. Drag the colour across the canvas – you won't get an even covering, but it's the variation that makes it interesting. Experiment with the angle of the scraper. Turn the canvas upside down and do the same the other way around.

(3)

(4)

Scrape excess paint off the scraper. Repeat the process with a fourth colour; I used cadmium yellow. Let the paint blend as you drag it across the canvas, but don't cover the first layer entirely. As you work, manoeuvre the scraper up and down. This will give the painting rhythm and texture, similar to the grain in wooden planks. This is what Richter does in order to break up the smooth horizontal of the paint.

I then went for the lightest colour, pure titanium white. Apply it directly from the tube onto the middle of the canvas, then drag it across the canvas with the wiped-down scraper. Don't reapply any paint, but turn the canvas upside down and drag the other way.

(5)

Use a palette knife, or whatever tool that works, to scrape an area of paint back to the bottom layer. Continue to apply paint and scrape back, until you are happy with the result.

Claude Monet: Using a simple palette to create a shimmering surface

It is easy to get lost in the intricate mesh of texture and colour that make up Claude Monet's large-scale pantings of water lillies. In this exercise, we are going to look at some of the techniques that Monet used to create this luminous lily pond.

RECOMMENDED PALETTE

- ○ Titanium white
- ● Cobalt blue
- ● Sap green
- ● Phthalo green
- ● Cadmium yellow
- ● Naples yellow
- ● Alizarin crimson
- ● Cadmium red

YOU WILL ALSO NEED

Primed canvas
Flat and filbert brushes
Palette knife
A solvent
Rags/paper towels

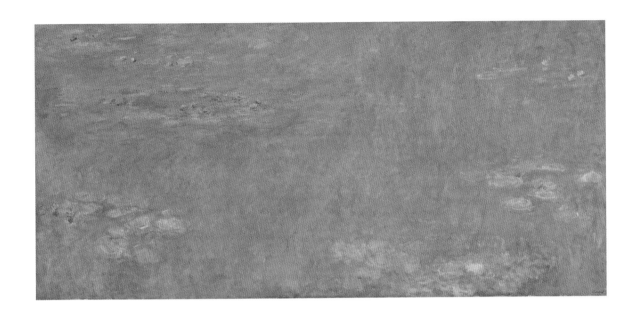

This painting is all about the surface. The subject may be a lily pond, but that is almost incidental – the real subject is the shimmering surface of colour and light created by Monet's distinct use of oil paint. There is neither a horizon nor a specific point of reference; we are simply engulfed by the greens, pinks and purples that hover in front of us.

Monet loved to paint outdoors, so much so that when he got older, he turned his beautiful garden at his home in Giverny into an outdoor studio. The water lily pond was Monet's great pride and the subject of over 200 paintings made towards the end of his life. Throughout his painting career, Monet had been fascinated by light and the effects of it in nature. Monet's lily pond gave him the perfect vehicle through which light's effects could be explored. Later in life, his eyesight began to diminish due to cataracts. He then developed a simpler palette and used all his experience and expertise to work these limited colours with an array of brushstrokes and marks to capture the spread of light on the water.

Water-Lilies after 1916

Claude Monet
oil on canvas

Thin down pure cobalt blue with a solvent, and use a flat brush to apply the paint in loose, vertical brushstrokes. This is a reflection, so the sky is at the bottom of the canvas. Leave this area blank.

Repeat Step 1 using sap green; this gives a rich, deep green. Add titanium white for the lighter area at the bottom of the canvas. Keep your brushstrokes vertical, let some of the green blend, but don't cover all of the blue. These vertical brushstrokes are important to give the effect of reflections, even though we can't see the edge of the water.

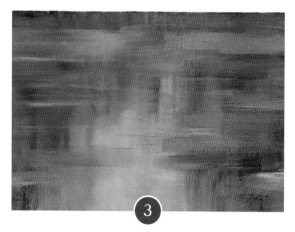

On your palette, mix phthalo green with a small amount of titanium white, without thinning your paint. Use a large flat brush to apply this mixture horizontally; the horizontal brushstrokes develop the effect of the water's surface. Repeat with Naples yellow. Don't blend the paint at either stage.

Ignore all the details at this point. With a medium filbert brush, use short, choppy brushstrokes in all directions to build up the surface of the painting. Don't be afraid of contrasts: let dark areas sit next to light areas.

5

Mix a tiny amount of cadmium red and alizarin crimson with titanium white to make a soft pink colour. With short, choppy brushstrokes, introduce this to the lighter areas of the painting, bringing it in next to the greens. The two colours together will help the green pop off the surface.

Use thick Naples yellow and cadmium yellow to create the lily pads, applying a smear of colour with a palette knife. You can use the same tool to scrape and scratch off paint to develop the texture of the surface.

Glossary

Abstract
A type of artwork with no recognisable or realistic subject matter.

Aerial (atmospheric) perspective
The illusion of depth, through the fading of tone and the slight addition of blue. Prevalent in High Renaissance paintings.

Alla prima
Literally translated, this is the Italian for 'at the first'. In art, it means the completion of a painting in one sitting, when the paint is still wet.

Blocking in
The loose application of thinned-down paint in the early stages of the painting.

Canvas
A common support for artists to paint on. It is normally stretched over a stretcher frame. It is textured, due to the weave of the fabric, and it comes in a variety of weights.

Complementary colours
Colours that sit opposite each other on the colour wheel. Complementary pairings always consist of one primary and one secondary colour. If you mix two primaries, the resulting secondary colour will be the complementary to the remaining third primary not used in the mix. (For example, blue and yellow mixed together make green; green is the complementary of red.) When placed next to each other, complementary colours stand out more and appear brighter.

Composition
The positioning of the pictorial elements of a painting to guide the viewer's eye to a focal point or to create a specific effect.

Cool colours
Colours that have a bluish tinge to them.

En plein air
En plein air simply means outside, but it really refers to painting directly from nature. This became prevalent in the mid-nineteenth century with the Realists, such as Gustave Courbet, and then the Impressionists, such as Claude Monet. Artists before them had painted outside but only to make studies for larger paintings that they would complete in the studio.

Form
The three-dimensional shape of an object.

Formal qualities
The 'formal qualities' in art are line, tone, colour, shape and texture. These are the building blocks of painting.

Gesso
Chalk held in suspension that can be painted on a support to prepare the surface for painting.

Glaze
A translucent mixture of paint and oil medium (sometimes with other ingredients) that is applied in layers to create a smooth blending of colours and tones.

Ground
The surface the painting takes place on. The support (such as canvas) will be prepared (for example, with gesso or primer) to make the ground. This can sometimes be coloured.

Hue
Another word for colour.

Impasto
Thickly applied paint. Impasto paintings are often done with palette knives.

Linear perspective
The way that objects appear to diminish in size the further away they are. In art, this creates the illusion of depth.

Linen
Similar to canvas, linen is a material woven from flax. It is usually stretched onto a frame. Its weave is usually finer than that of canvas.

Medium
Term used to describe different types of paint or ways of making artwork. It is also a substance that can be added to your oil paint to change its consistency or fluidity and make it more translucent. Used in the making of glazes.

Mid-tones
The middle tones between the darkest and lightest tones.

Modelling
The use of light and dark to create a sense of three-dimensional form.

Modulating
Adjusting the tone of a colour, by adding lighter or darker paint, to create the impression of a three-dimensional form.

Palette
Term that can refer to the colours used in a particular painting (colour palette), or to the object on which the paints are mixed.

Perspective
Perspective is the illusion of depth (three dimensions) created on a two-dimensional surface. There are two types of perspective: linear and aerial.

Pigment
The coloured substance, usually powder, that is mixed with a medium to make paint.

Primary colours
Three colours that can't be made or mixed. They are red, blue and yellow.

Primer
The first paint that goes on your support to create a suitable ground for painting on.

Representational
A type of painting that is realistic.

Scumble
Applying a thin layer of paint over another layer, allowing the colour underneath to still show through.

Secondary colours
A colour made by mixing together two primary colours. The secondary colours are orange, green and purple.

Shade
Darkening a colour by adding black or another dark colour.

Solvent
A substance that dissolves or thins the paint. For oil paint the traditional solvent is turpentine (made from tree resin), but mineral-based solvents, such as white spirit, can be used.

Stand oil
An oil medium.

Stretcher
A square or rectangular frame, made of stretcher bars, onto which canvas or linen is stretched and attached.

Subject matter
The object or person or place that is the main focus of a painting.

Support
Anything that you paint on. The most common support is canvas, usually on a stretcher frame.

Tint
Lightening a colour by adding white.

Tonal gradation
The transition, usually smooth, from one tone to another.

Warm colours
A range of colours with a red or orangey tinge.

Picture Credits

Acknowledgements

I would like to dedicate this book to Philip Woolley, the best art teacher I had, who inspired and instructed me in equal measure. I wouldn't be doing what I do now if it weren't for him.

And thank you to my wonderful girlfriend Caroline, who was so helpful and patient throughout this whole process.

Thank you also to Zara Anvari and Steph Hetherington, my Editors at Ilex, whose hard work and advice were invaluable.

And finally, thank you to the Tate and everyone who makes their galleries the best in the world!

An Hachette UK Company
www.hachette.co.uk

First published in Great Britain in 2019 by Ilex, an imprint of
Octopus Publishing Group Ltd
Carmelite House
50 Victoria Embankment
London EC4Y 0DZ
www.octopusbooks.co.uk
www.octopusbooks.com

Distributed in the US by
Hachette Book Group
1290 Avenue of the Americas
4th and 5th Floors
New York, NY 10104

Distributed in Canada by
Canadian Manda Group
664 Annette St.
Toronto, Ontario, Canada M6S 2C8

Publisher: Alison Starling
Editorial Director: Zena Alkayat
Managing Editor: Rachel Silverlight
Junior Editor: Stephanie Hetherington
Art Director: Ben Gardiner
Picture Research: Giulia Hetherington and Jennifer Veall
Production Manager: Caroline Alberti

Ilex is proud to partner with Tate; supporting the gallery in its mission to promote
public understanding and enjoyment of British, modern and contemporary art.

ISBN 978-1-78157-655-7

A CIP catalogue record for this book is available from the British Library.

Printed and bound in China

10 9 8 7 6 5 4 3 2 1